PRAISE FOR
OASIS IN THE MOUNTAINS

Lorrie Bortner's work invokes a calming and settled response. A graceful moment where time stands still. All forms of life created, live in harmony. People, animals, even trees happily seem to watch our world as they slowly float by. Viewed by us in greater glory of innocent beauty for their trouble.

It is a place of rounded edges and cool tones. Rich with deep colors. The eyes, leaves, animals and people smoothly flow and allow us to float along with them like a dream but hauntingly close to an experience one calls back from a real or imagined past.

—Thomas J. Johnson
Painter and printmaker

Lorrie's art are reflections of her self. Reflecting her personality, full of life, color and pure love. Her art refreshes your soul, makes you smile, always fun. You always feel pure love. Sweet Lorrie.

—Lydia Garcia
Santera

Lorrie Bortner's work is fresh and delightful.

It is a reflection of who she is, which is very rare in these days of assumptions and pretensions.

While her work shows a directness and may seem almost childlike, which is a feat in itself, her vision and knowledge is anything but.

Bortner tells a mythological story or broaches upon a topic she deems important to her, yet it is never propagandistic. It always comes down to aesthetics in the end, which in my opinion is what art is about.

We are lucky Lorrie chooses to be real and honest, for through her truthfulness we get rich, colorful, fun and astute paintings.

—**Brenda Euwer**
Abstract painter

It's easy to see why so many people are drawn to Lorrie's work. The bold colors and playful images create a world of color and life that enables us to travel, getting lost in the thoughts that the images create. The colors and images are in motion and they mesmerize, as if reminding us of a vision, or a dream we once had. Her work can be whimsical, yet powerful and bold, brave enough to address women's issues, and yet whimiscial enough to invoke the joys of a childhood too soon forgotten.

—**Carmela Duran**
Museum Coordinator
Millicent Rogers Museum
Taos, New Mexico

Lorrie paints with great focus and determination, has an original vision and can render subjects of great complexity with remarkable simplicity and forcefulness: she is, in fact, a natural heir to the early expressionists.

—**Geoffrey Baker**
Professor Emeritus of Art
Maharishi University of Management

Oasis in the Mountains

The Paintings of
Lorrie Bortner

Oasis In the Mountains

The Paintings of Lorrie Bortner

Edited by Kathryn Bell

© Lorrie Bortner 2009

Published by 1stWorld Publishing
P.O. Box 2211, Fairfield, IA 52556
tel: 641-209-5000 • fax: 866-440 5234
web: www.1stworldpublishing.com

First Edition

LCCN: 2008942967

ISBN: 978-1-4218-9049-4
eBook ISBN: 978-1-4218-9050-0

All rights reserved. No part of this book may be reproduced or utilized in any form or by any means, electronic or mechanical, including photocopying or recording, or by any information storage and retrieval system, without permission in writing from the author.

This material has been written and published solely for educational purposes. The author and the publisher shall have neither liability nor responsibility to any person or entity with respect to any loss, damage or injury caused or alleged to be caused directly or indirectly by the information contained in this book.

List of Paintings

Animals
1. Magpie Over Cundiyo
2. Autumn Rabbit and Buffalo
3. Spring Rabbit Run
4. Animal Whispers
5. Miss Polka Dot
6. Taos Animals
7. Deer and Fish
8. Tonto
9. Fauvist Winter
10. Yucan's Field
11. Sunrise Aria
12. Laughing Lizards
13. Pelicans

Trees
14. Transparent Life
15. Winter Tree
16. Beautiful Tree
17. Tree of Life – Night

18. Untitled
19. Transparent Life II
20. Fish Forest II
21. Double Fish Tree II
22. Tree of Life – Deer
23. Tree of Life
24. Tree of Life – Abstract
25. Animal Time

Spirit
26. Peace Levitation
27. Women Watching Buffalo Dance I
28. Women Watching Buffalo Dance
29. Deer Dance
30. Buffalo Dance
31. Tierra Madre
32. Spirit Watch

Women
33. Peace Meditation
34. Homage to Ramona
35. Taos PowWow Women
36. Taos Woman on Dog

37. Woman in the Moonlight
38. Taos Mother, Daughter & Chickens
39. Woman Riding Garuda
40. Chiapas Woman and Corn
41. Taos Woman with Dog and Chickens
42. Women Seasons
43. Mexican Market

Murals
44 Tree of Life Mural

ABOUT THE ARTIST

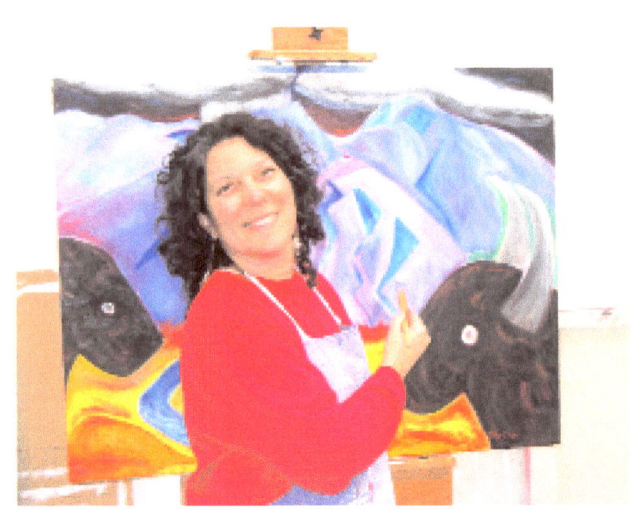

Lorrie was born in Philadelphia in 1955. As a child she lived in New Jersey, Chicago and New York. She always wanted to be an artist. Her early memories are of museum visits with her family to the museums in New York City, Chicago and Philadelphia.

As an adult she obtained an MFA in painting and an MA in education. Painting, creating murals and inspiring and teaching children the arts are her passion. She has received grants and community funding to create over 16 murals with New Mexico youth, thereby teaching the youth teamwork, creative thinking, artistic design and community service. Lorrie has also taught fabric painting, recycled sculpture and colcha embroidery, (a traditional northern New Mexico stitch), in the Taos, New Mexico schools.

Her paintings have been shown in exhibitions around the country and in museums including the National Hispanic Cultural Center (with Rainbow Artists), Albuquerque, New Mexico; El Museo Cultural de Santa Fe, (Aun Nos Atrapan), Santa Fe, NM; Museum of Fine Arts, (One of a Kind), Santa Fe, NM;

Millicent Rogers Museum, (Sobre Muerte and Miniatures), Taos, NM; and Cedar Rapids Museum of Art, (with Women's Caucus for the Arts), Cedar Rapids, Iowa.

For further information go to **www.lorriebortner.com**

ARTIST'S INTRODUCTION

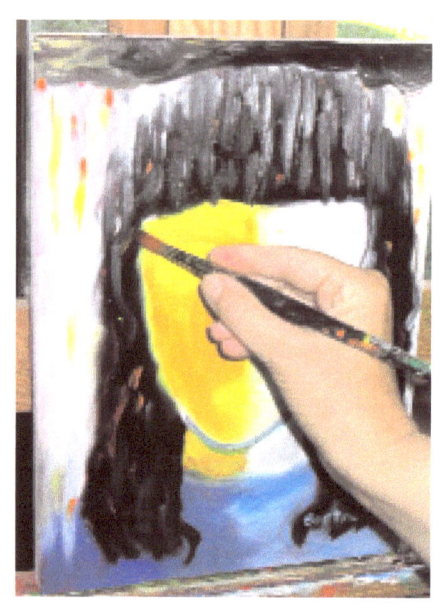

Every artist must select from the various elements in art. I am interested in color, shape and rhythm, giving prominence to these fundamentals to create an artistic whole. With these elements I create a magical place. My paintings are contemporary with a symbolic flavor.

The paintings are inspired by my travels in Mexico, India, and the Southwest. I have traveled in Mexico, including villages in the cloud forest, near San Cristobal de Las Casas, and the villages around Oaxaca. There are many colorful weekly crafts markets and traditional celebrations. I also hiked to the Santuario de Mariposas el Rosario, in eastern Michoacan. This was a spectacular site. Every inch of one's perception is filled with monarch butterflies. Another experience was whale watching in a small boat in the Bay of Banderas. Such huge animals next to our small boat. I spent 4 months in Delhi, India, in meditation, exploring Old Delhi and attending festivals. In my travels I also visit archeological sites. Now living in the Southwest I attend Pueblo feast days and traditional Native American dances.

The art of Mexico and India, folk art and children's art also are an inspiration

to my creative process. I use animal images to remind us of our kinship to nature. I paint human eyes on my animals to express this connection.

My images are lyric, poetic creations. A theme that interests me is the place of the feminine in the universe. I paint images that enhance the appreciation of the feminine energy in our world. My subjects are real women, but I explore universal archetypes by painting the faces as shapes and colors without features. The individuality is removed and the universality remains.

Another archetypical theme that I explore is the tree of life. This multicultural image symbolizes life and creation. I began using this image over ten years ago and it still appears in some of my paintings.

I use under painting, layering one or two colors. The colors below have an influence on the final image. I often add a texture to the color of the under painting.

Painting makes me happy. It is an external expression of the joy I feel.

I hope others can feel this in my art.

Lorrie Bortner

Taos, New Mexico

2008

ANIMALS

Looking into the eyes of animals, I see our connection to all of nature. When I paint animals I try to convey the interconnection of us all: human, animal, land, sky, water and the divine.

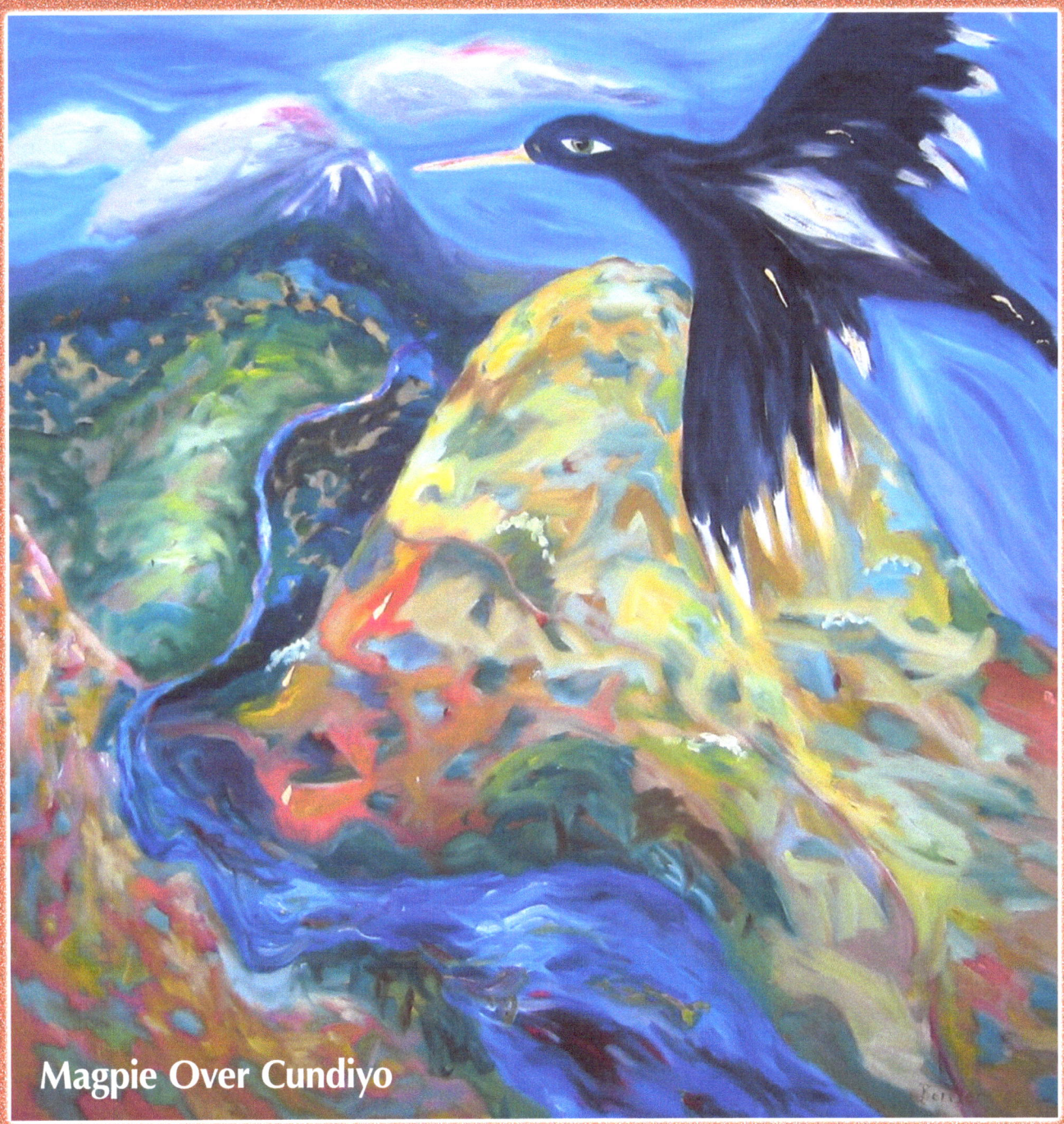
Magpie Over Cundiyo

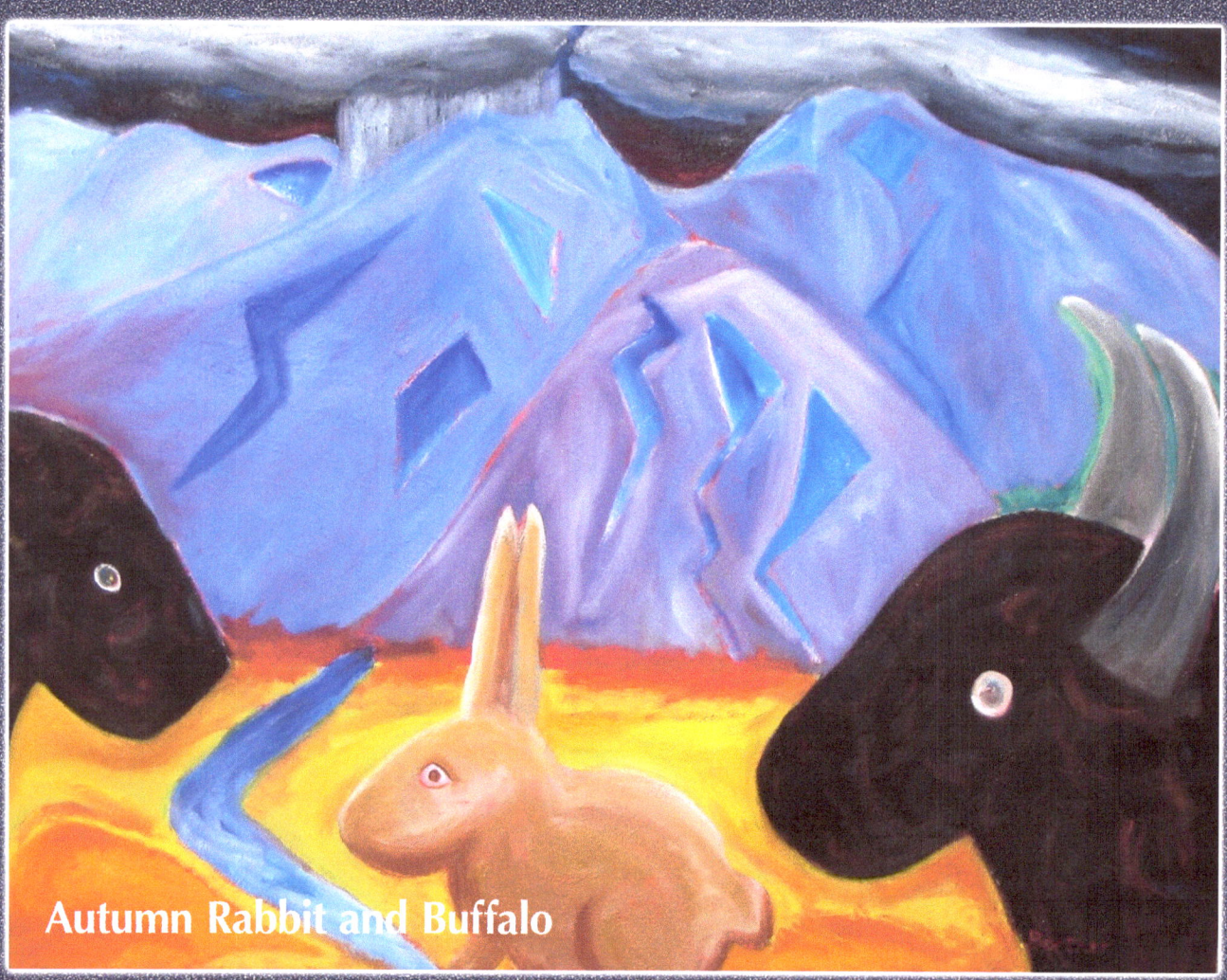
Autumn Rabbit and Buffalo

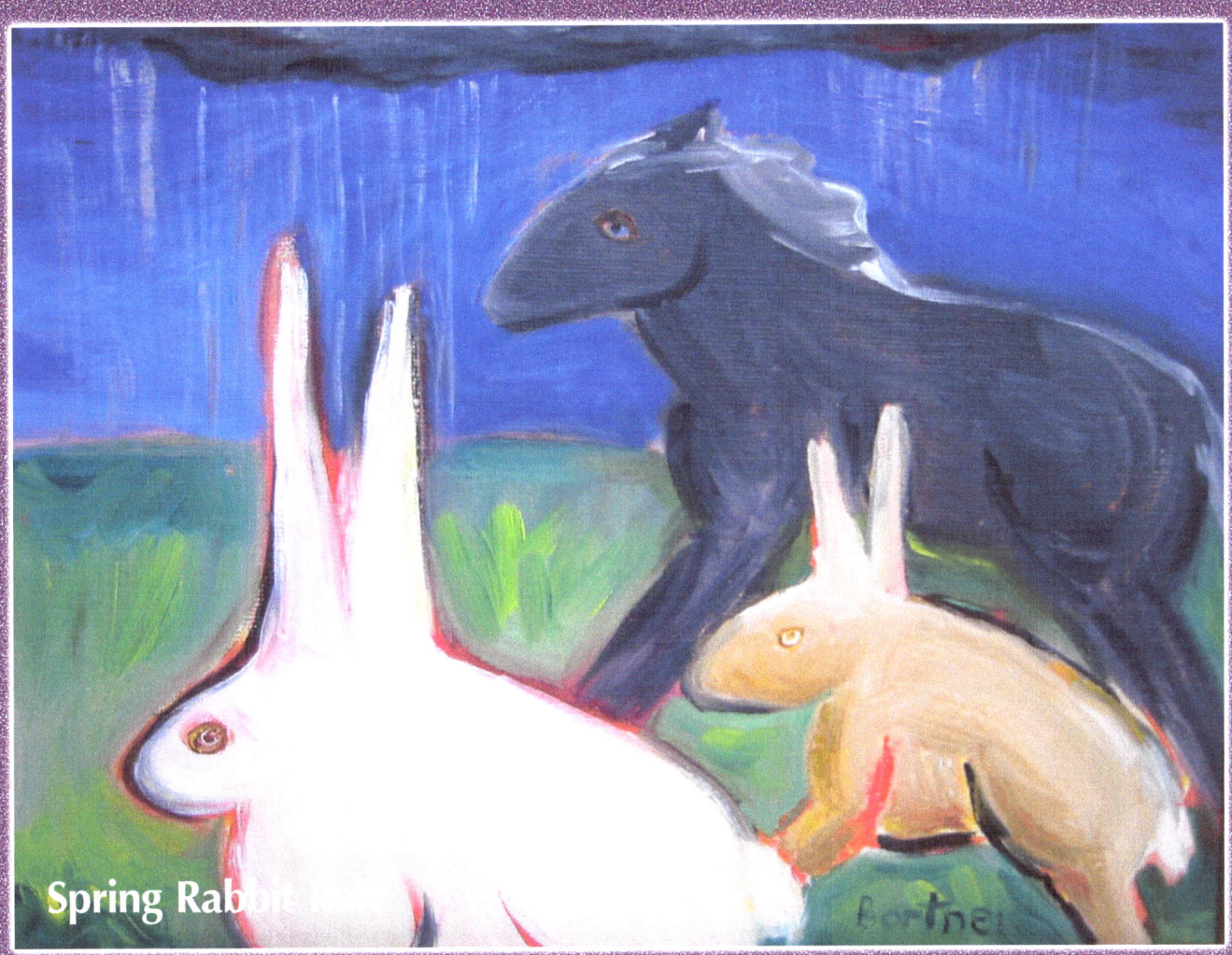
Spring Rabbit Run

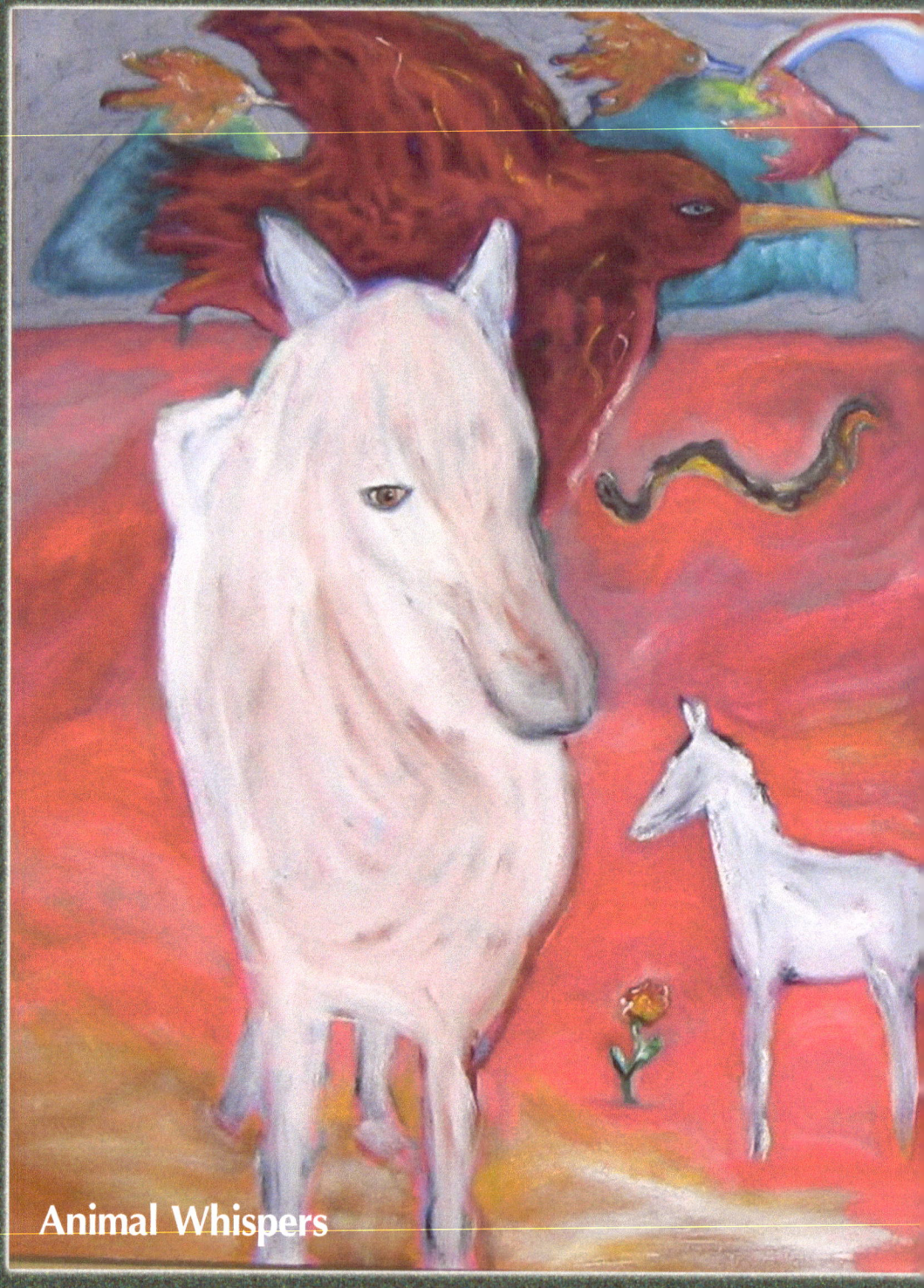

Animal Whispers

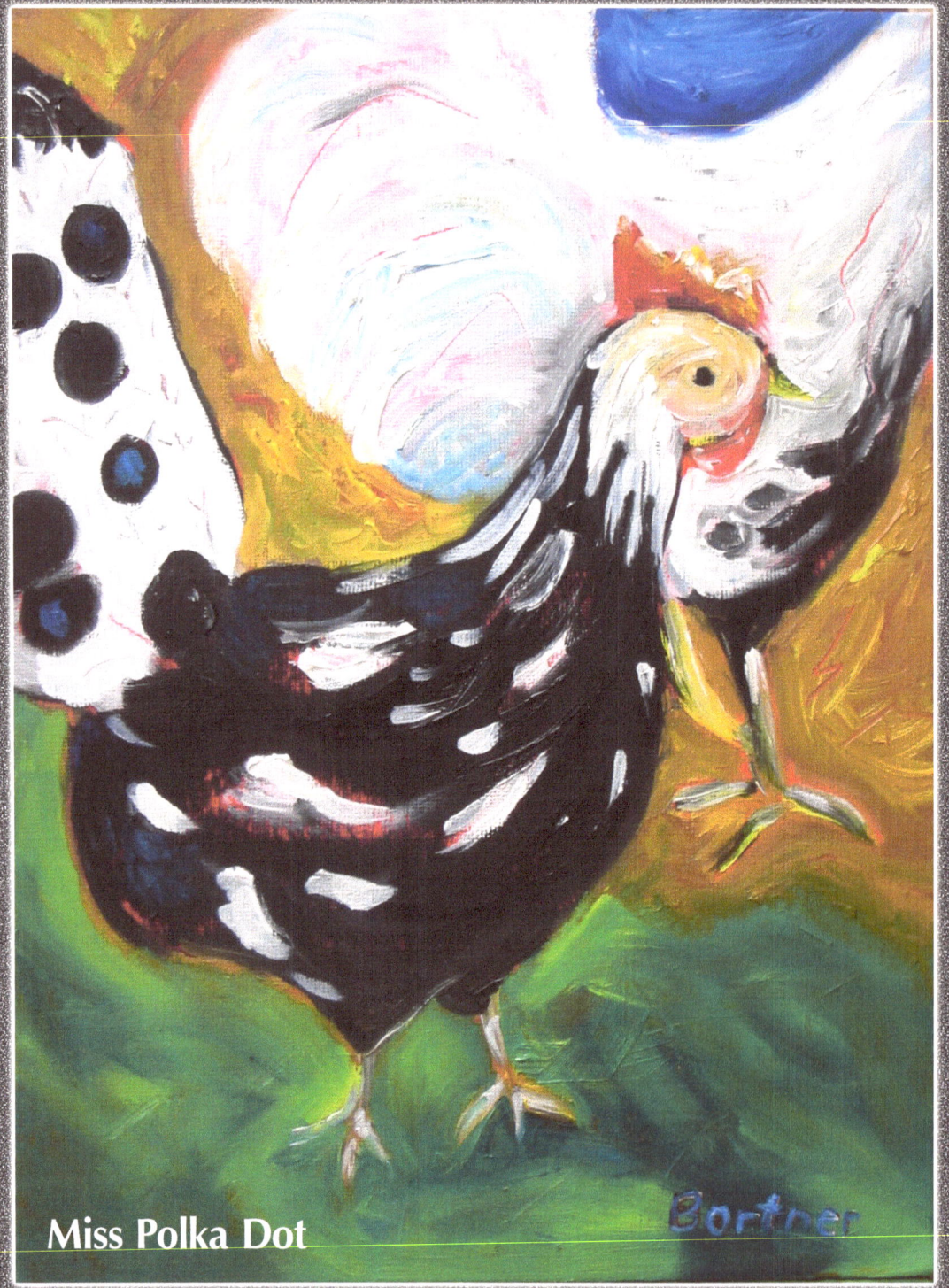

Miss Polka Dot

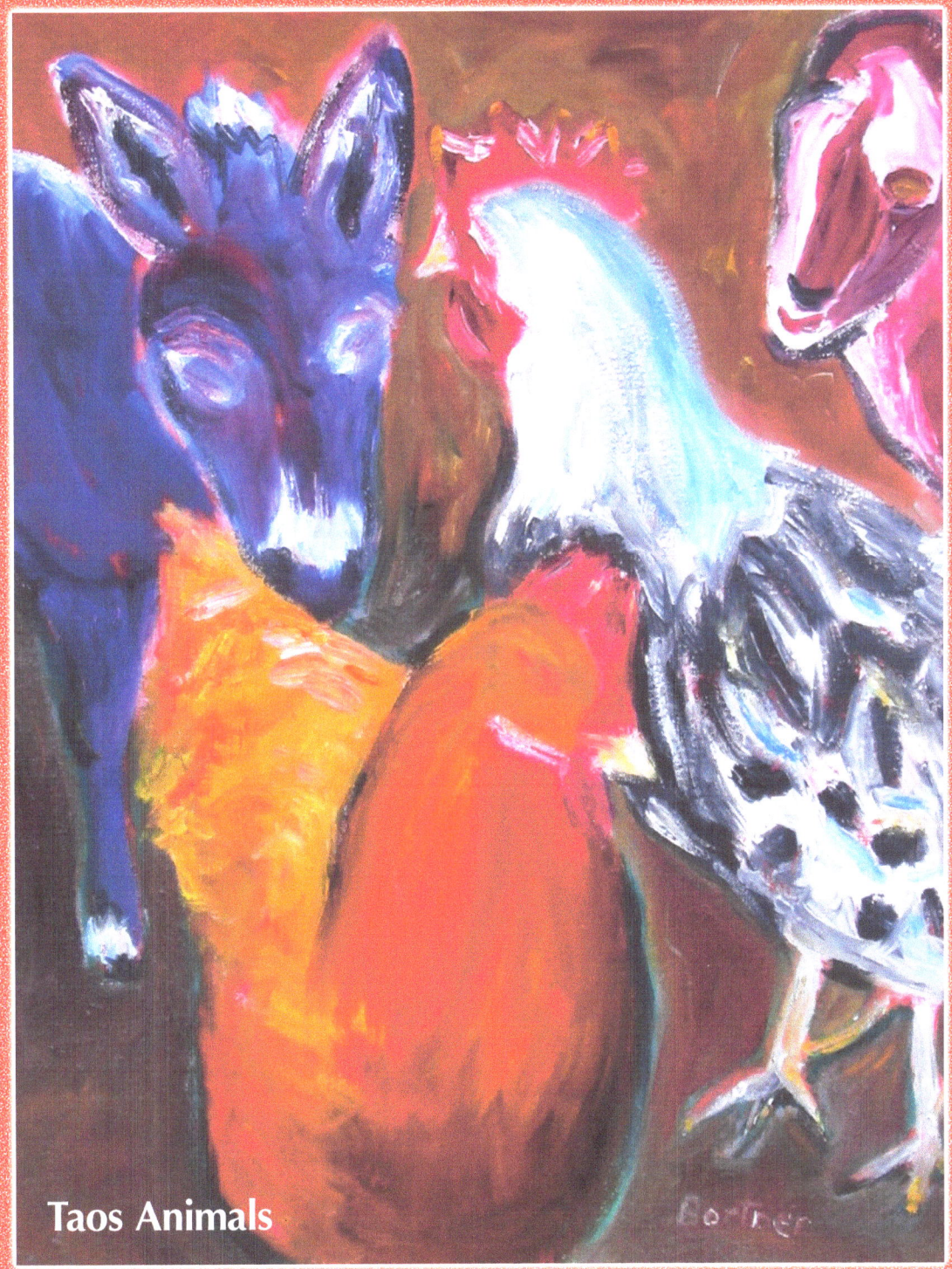

Taos Animals

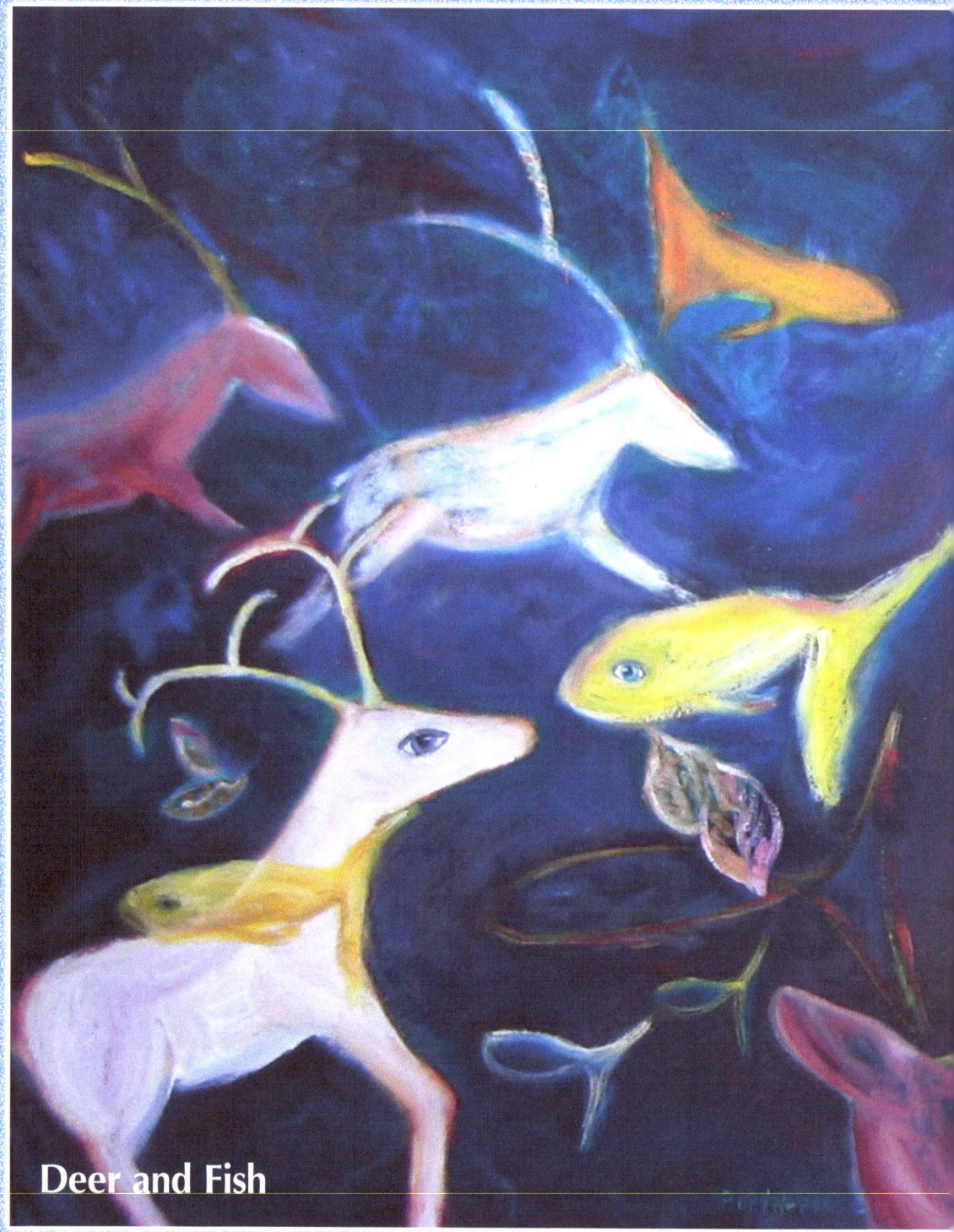

Deer and Fish

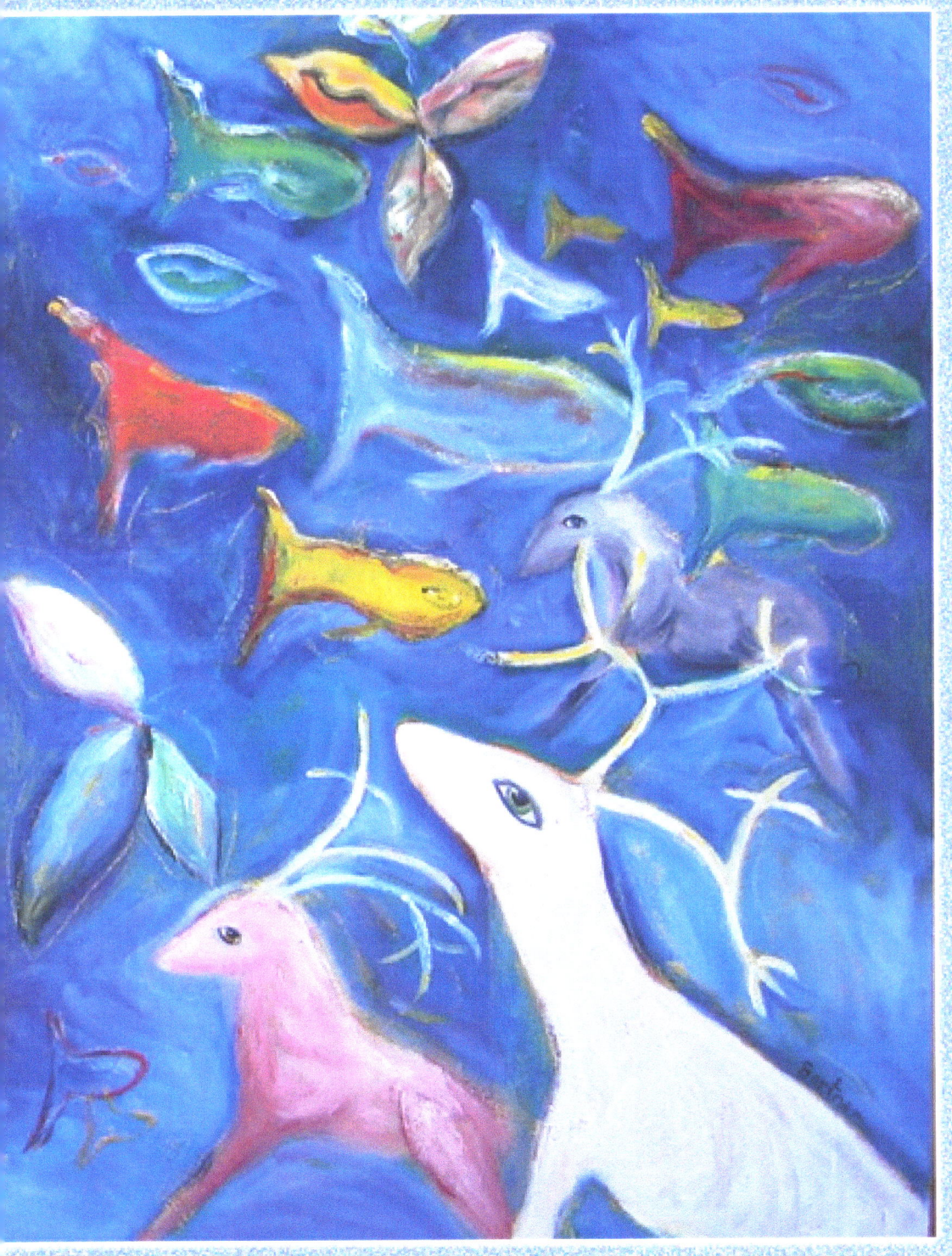

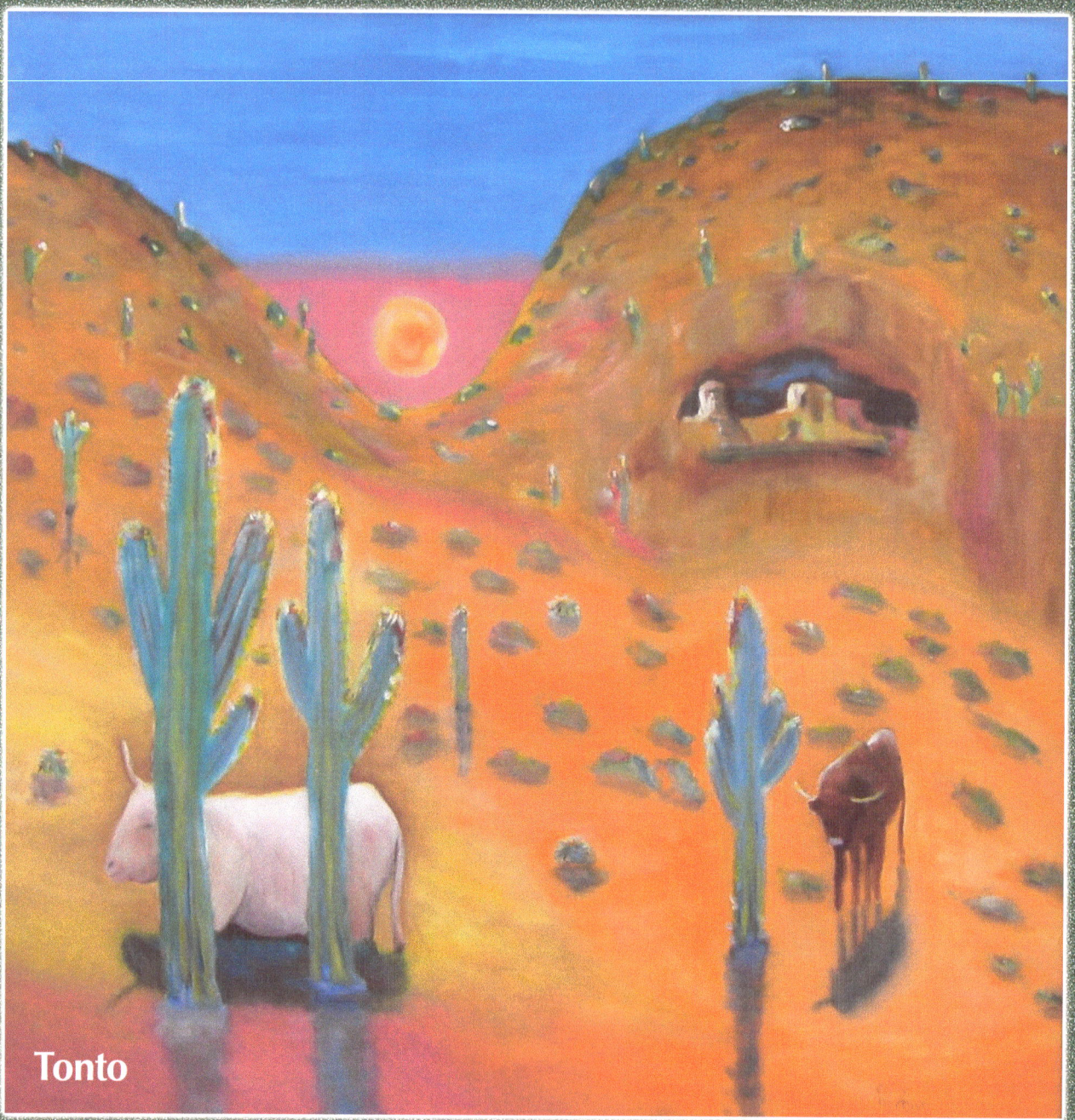
Tonto

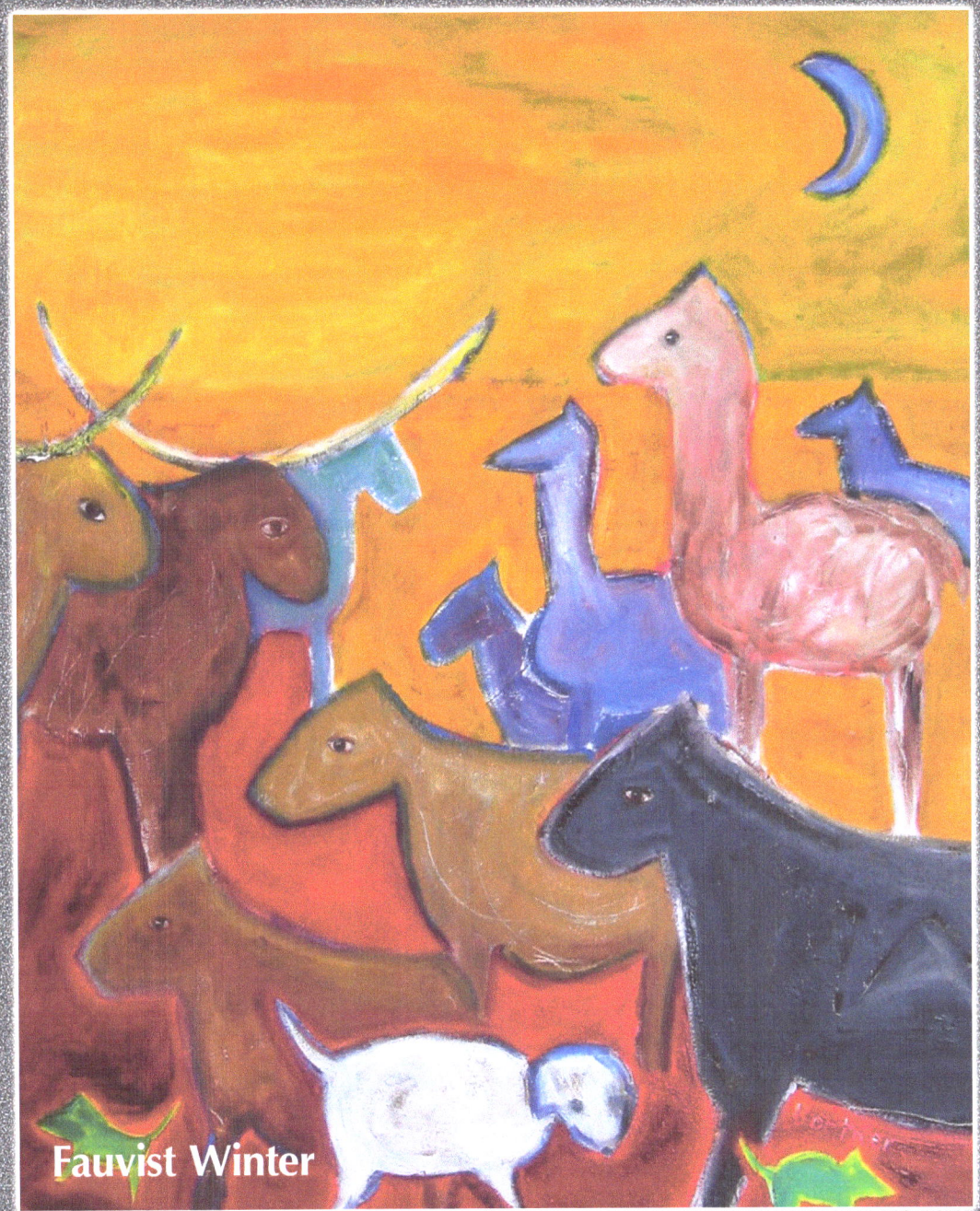

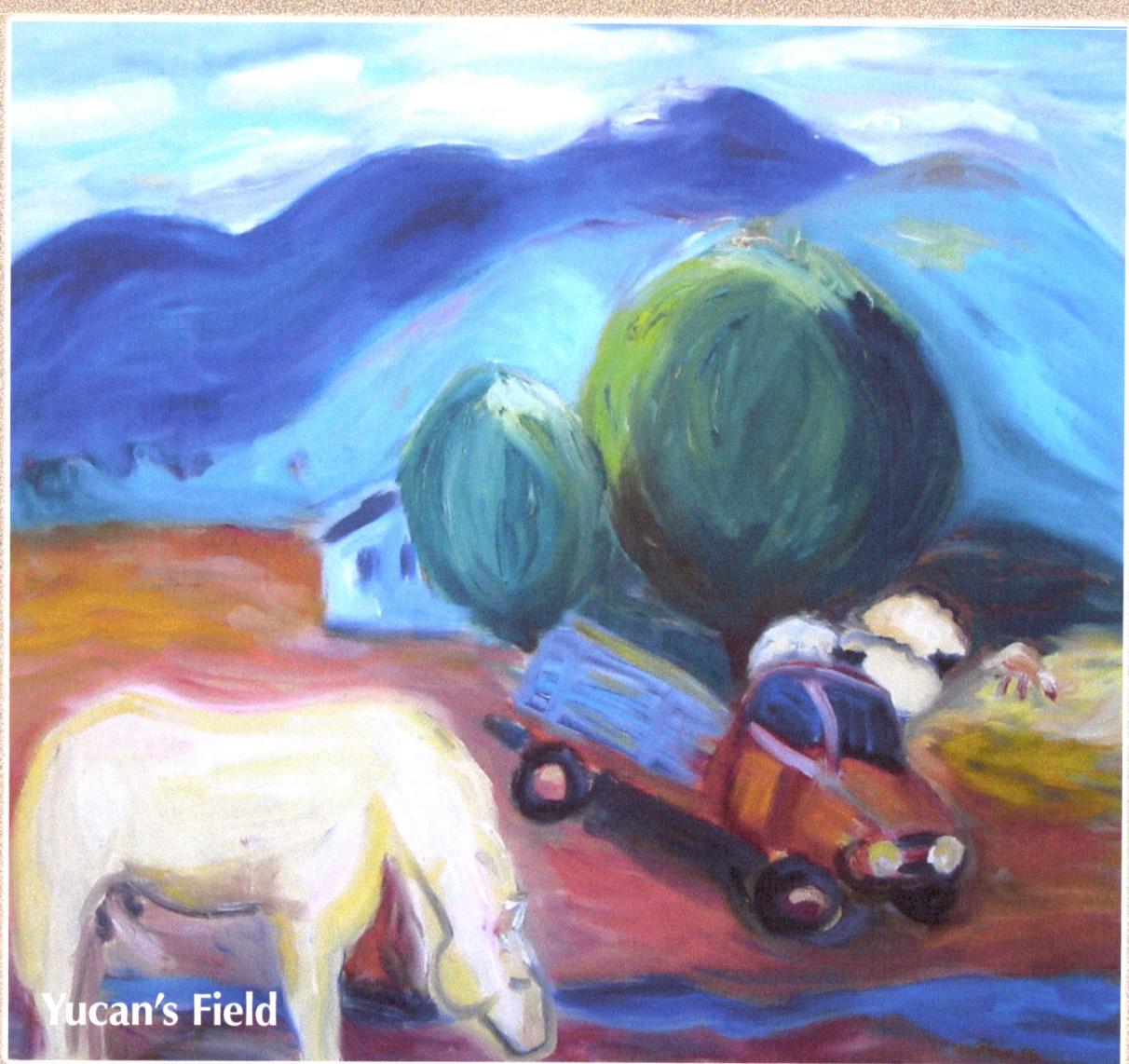
Yucan's Field

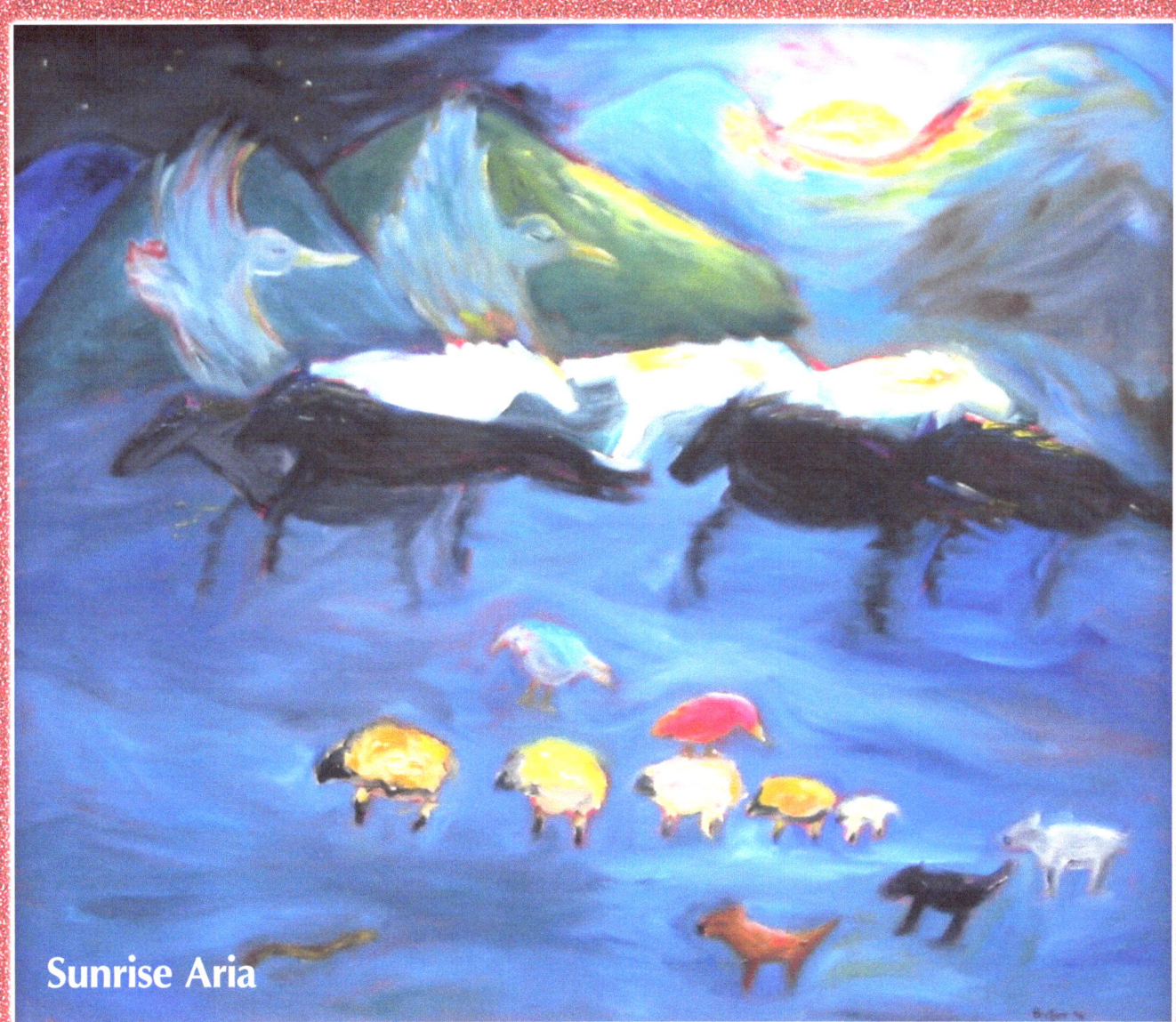
Sunrise Aria

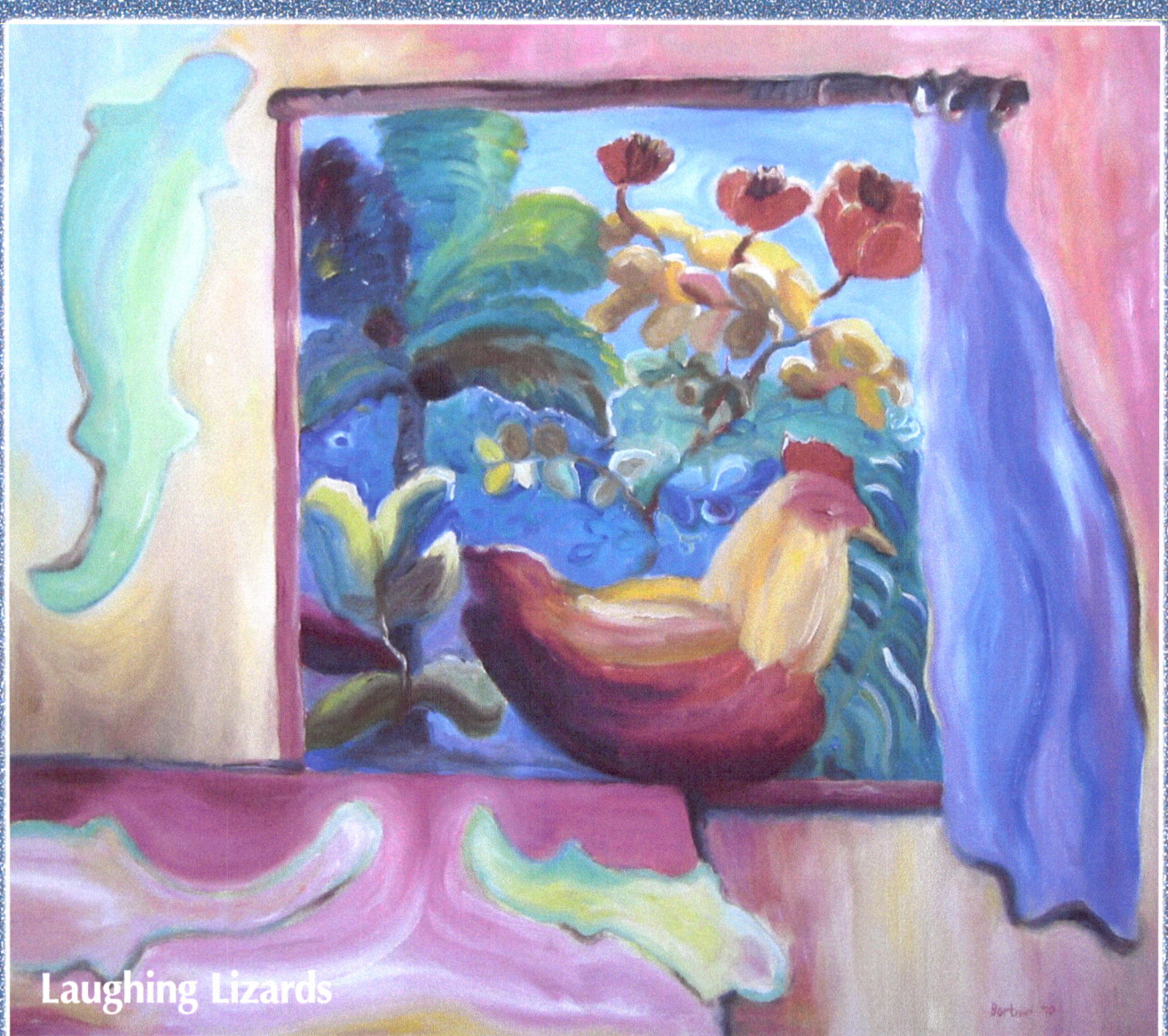

Laughing Lizards

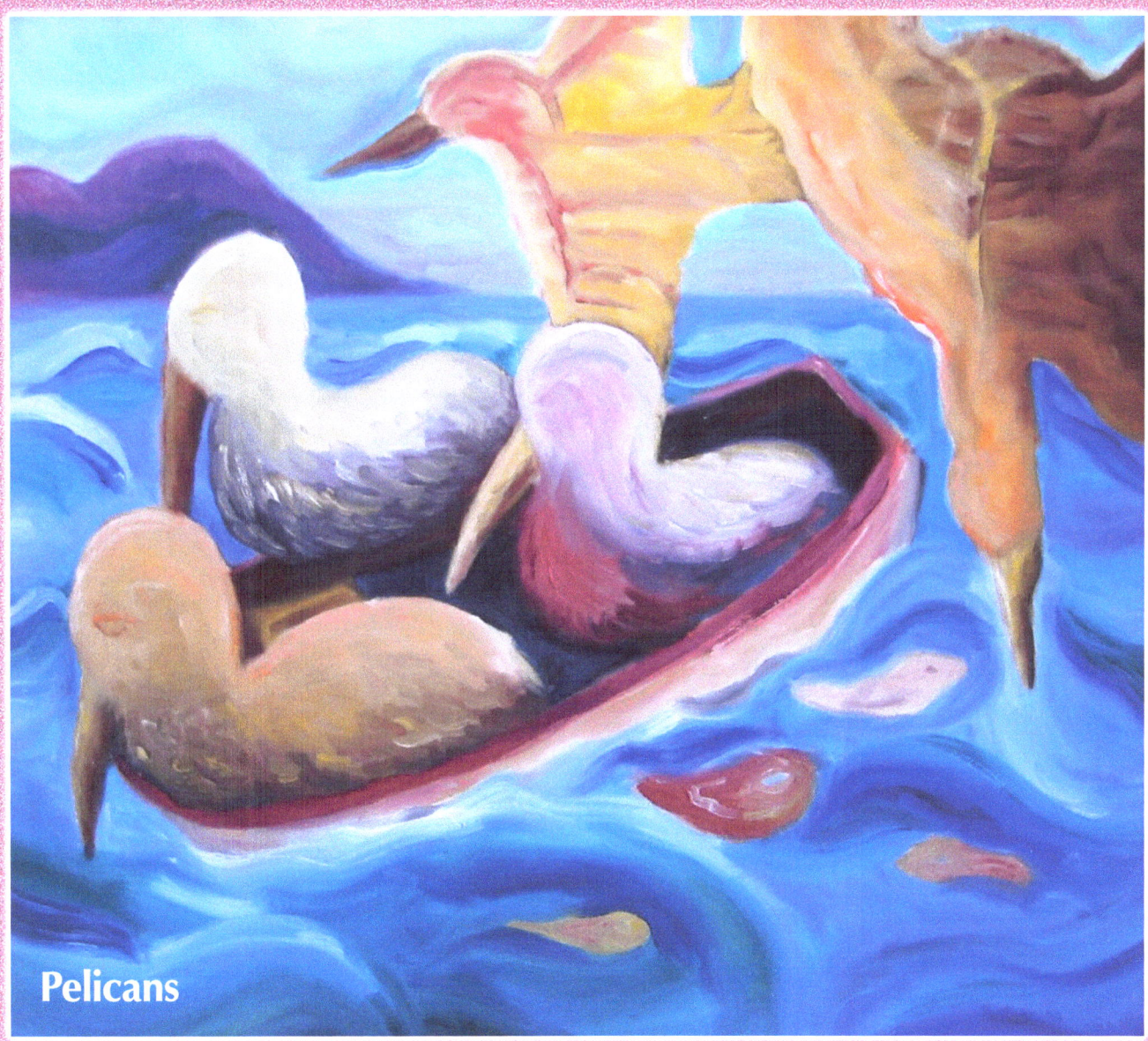
Pelicans

TREES

Trees sustain our Earth. Their roots go deep into the land while their branches reach toward the sky. They express the entire cycle of creation. My *Tree of Life* paintings explore this cycle of life. I love to stand under a tree on a hot day. Coolness and peace radiates from them.

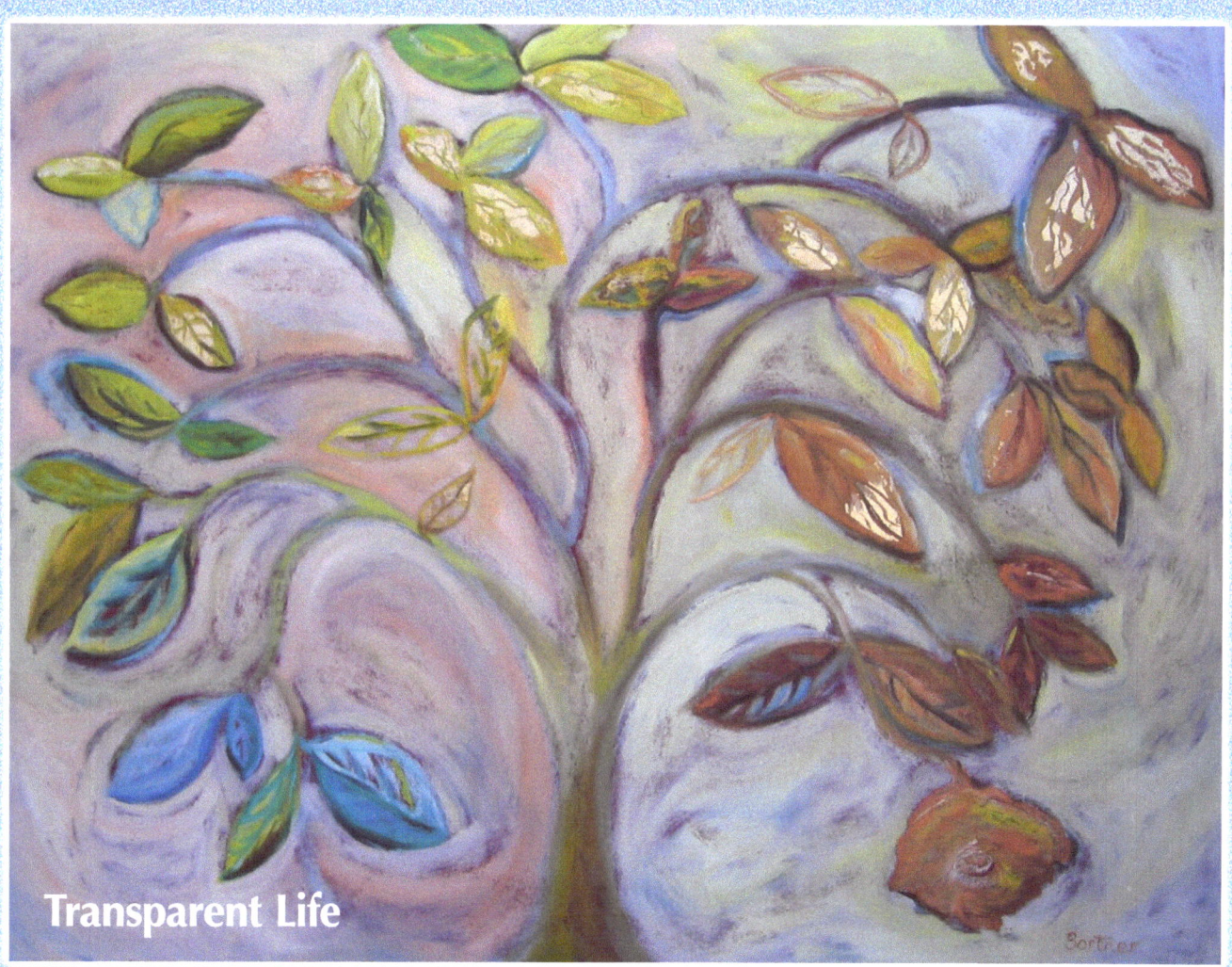
Transparent Life

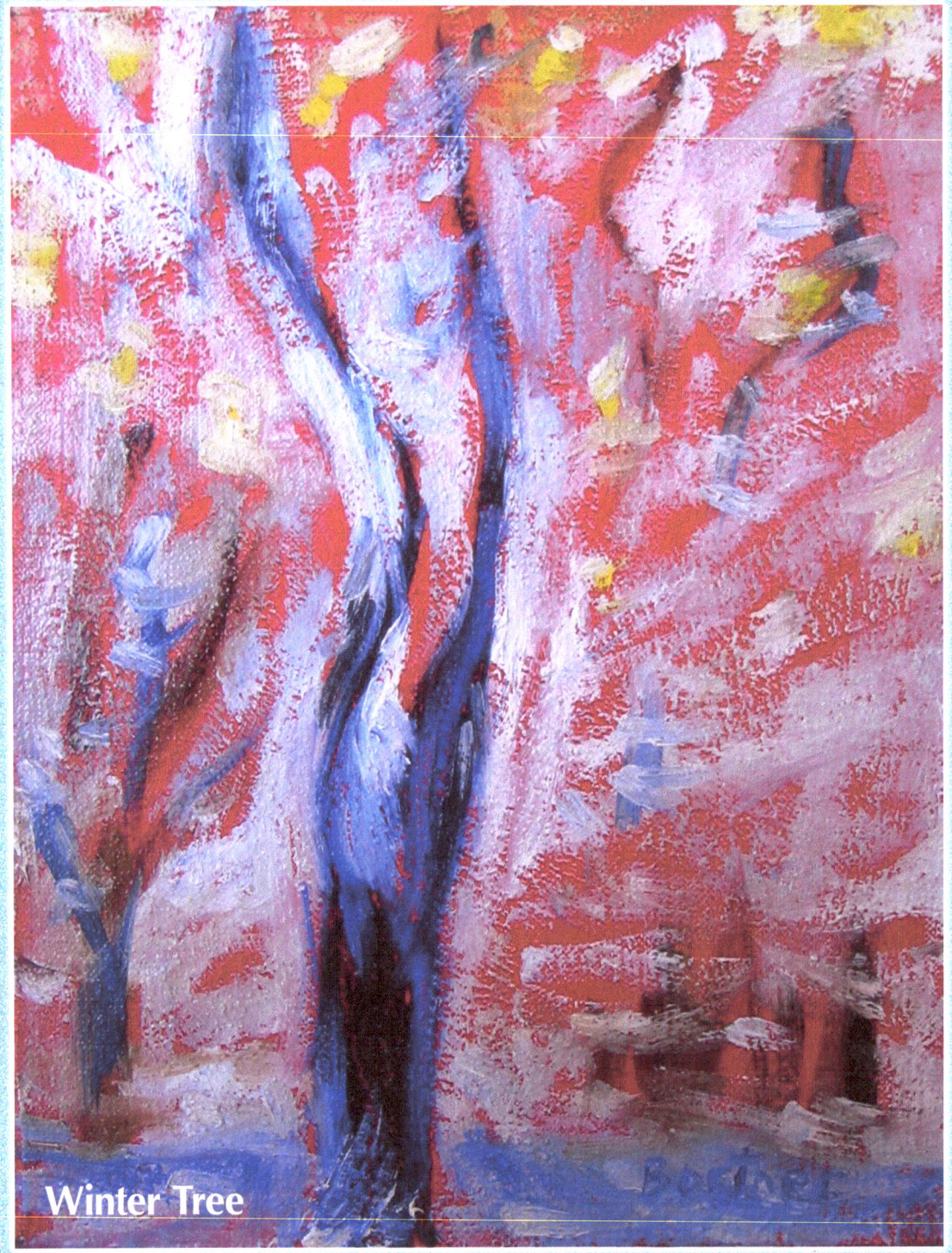

Winter Tree

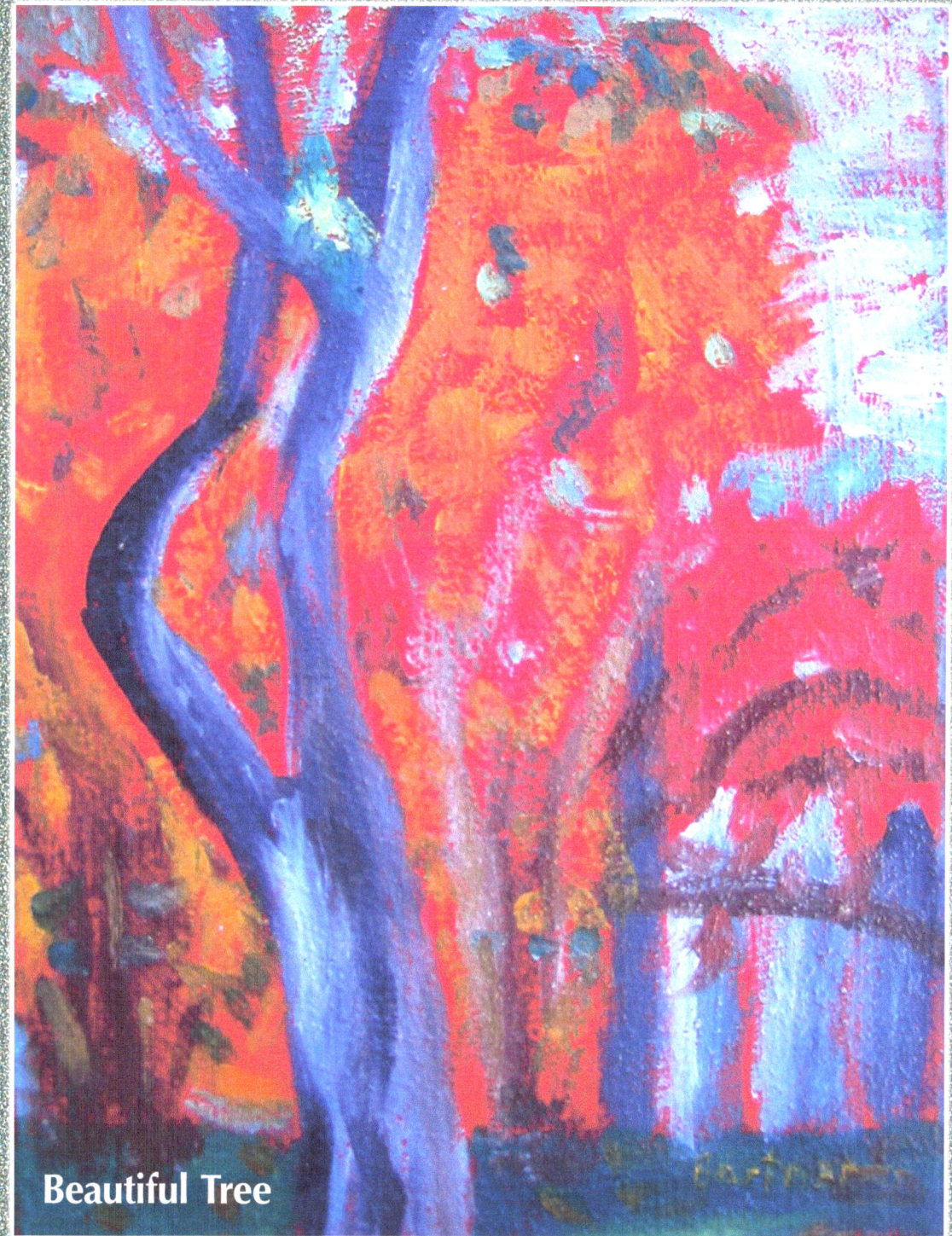

Beautiful Tree

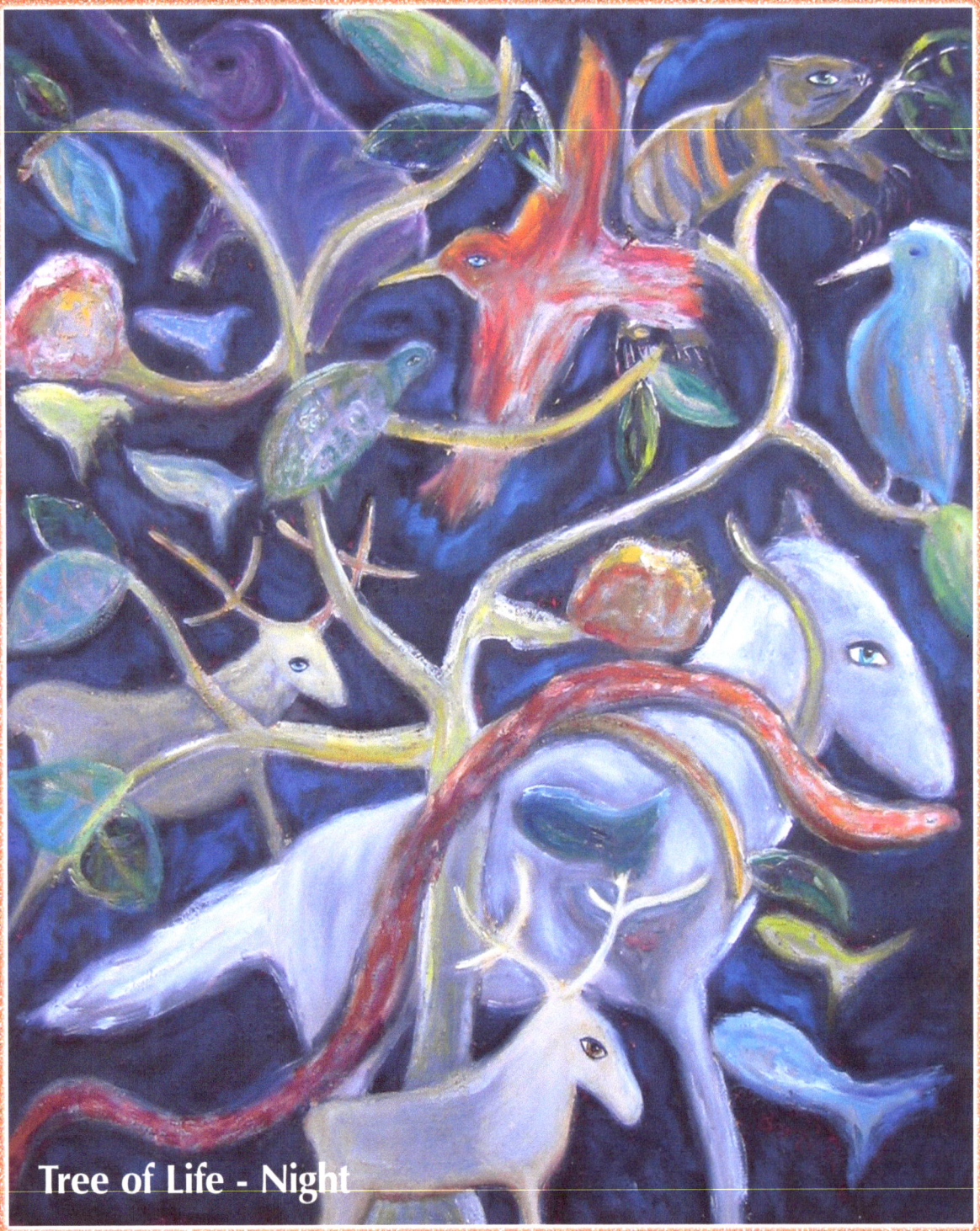

Tree of Life - Night

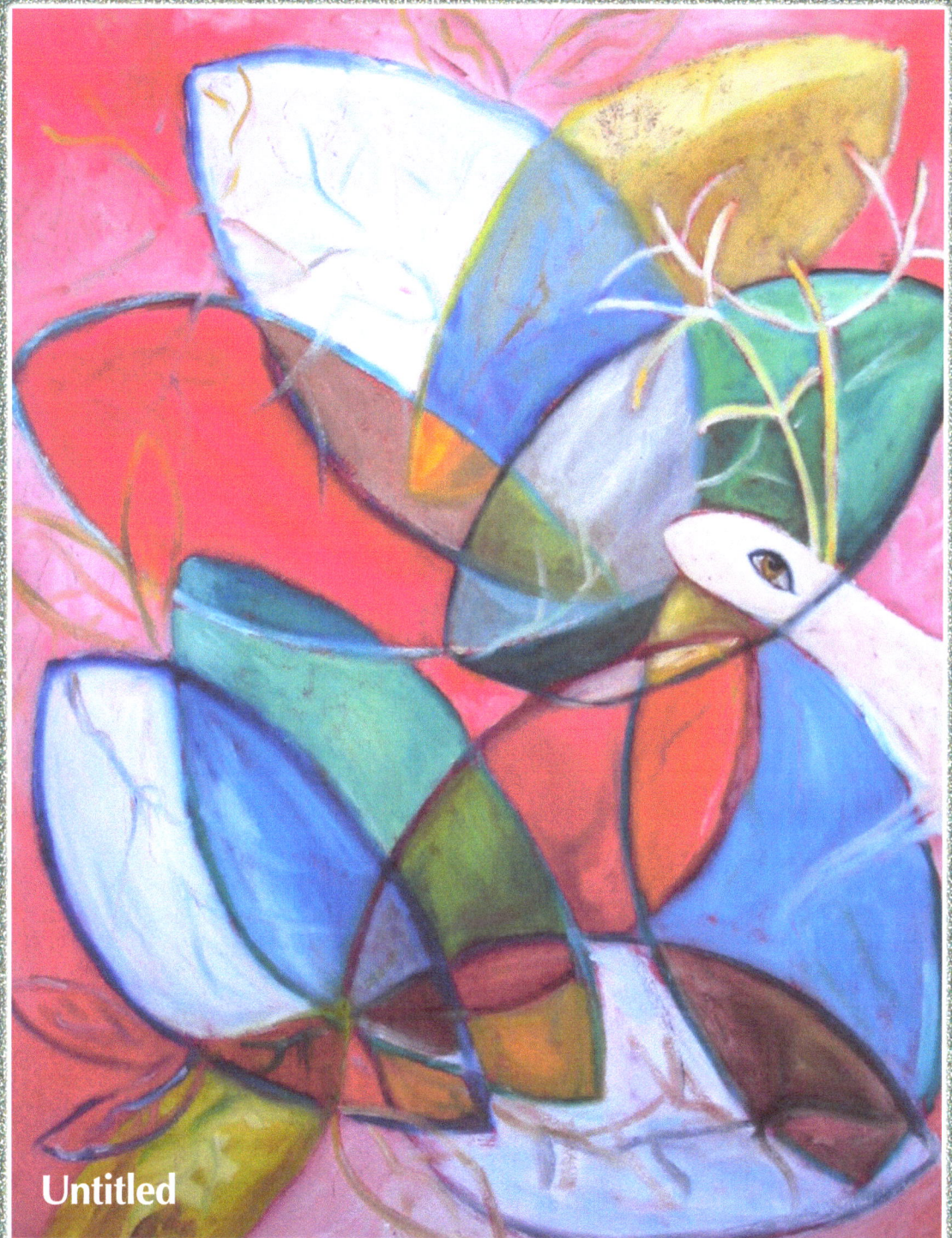

Untitled

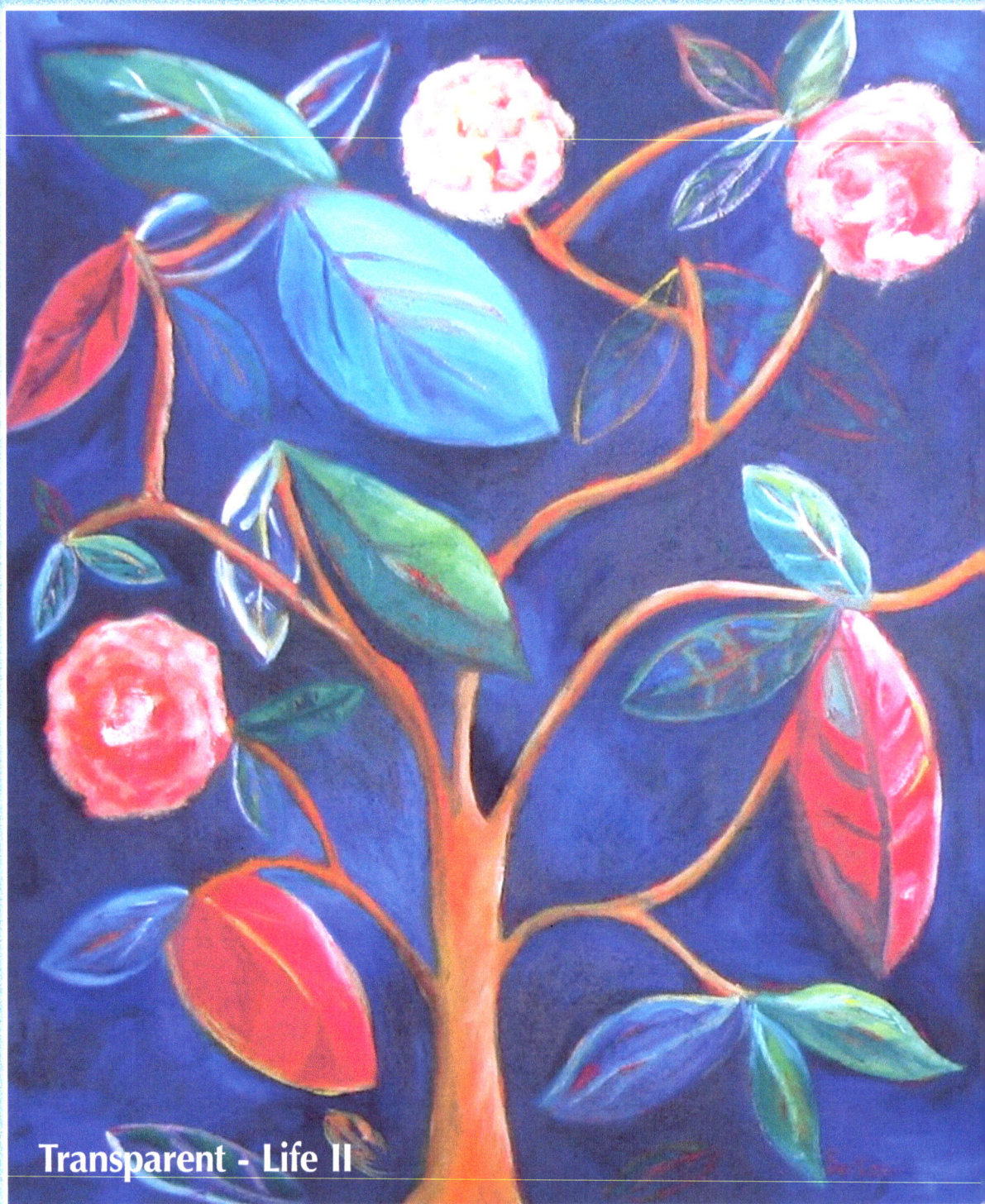

Transparent - Life II

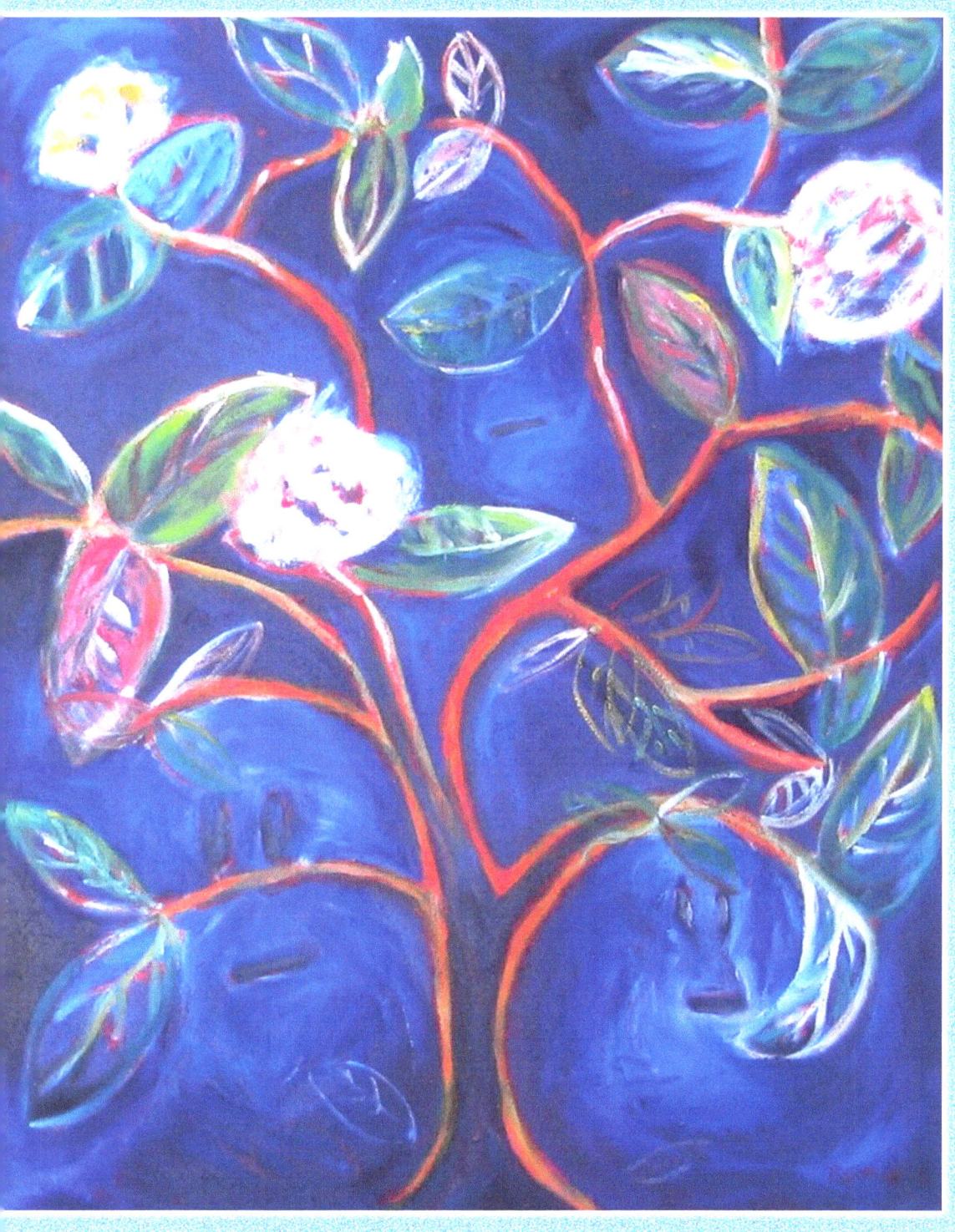

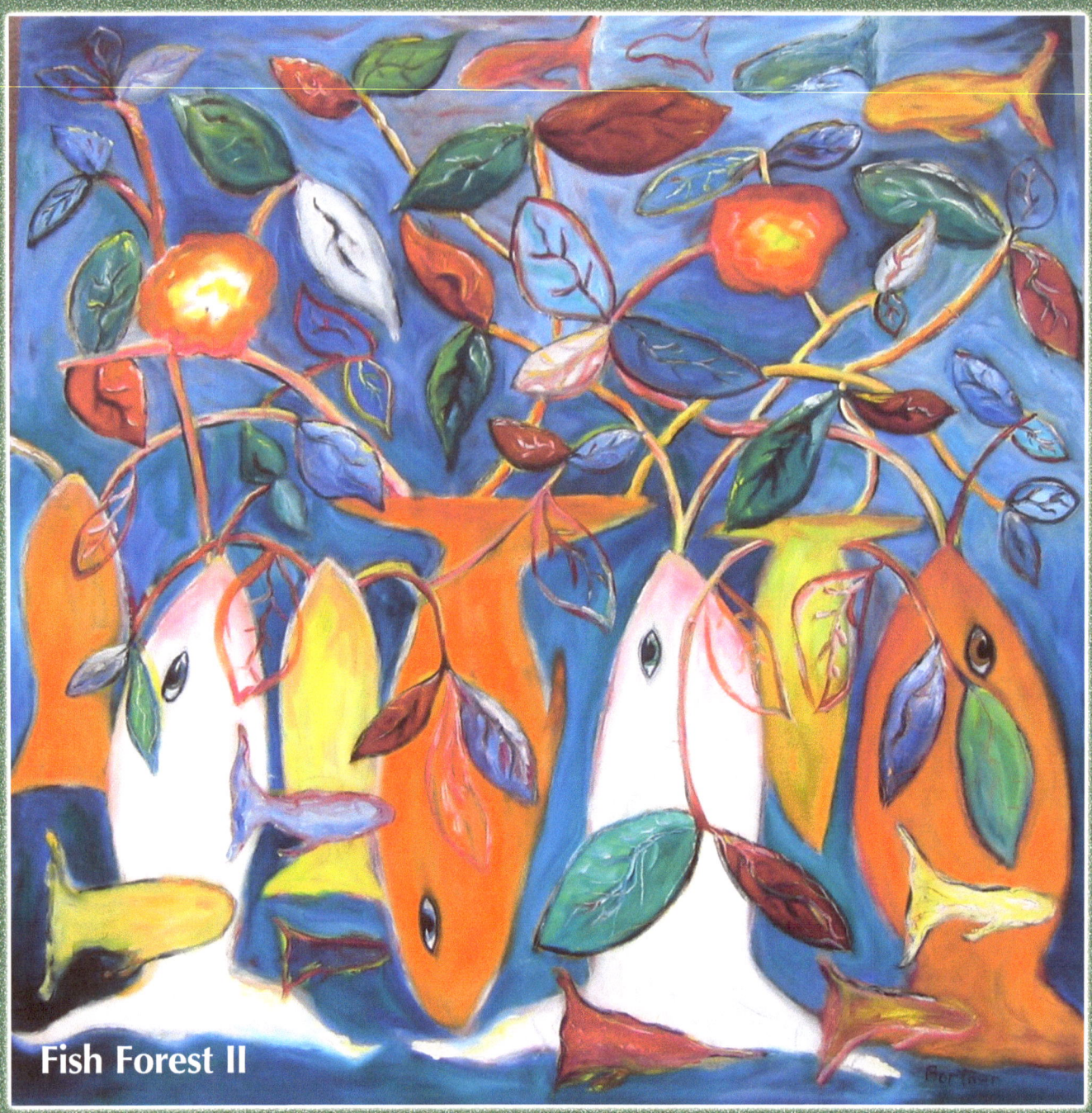
Fish Forest II

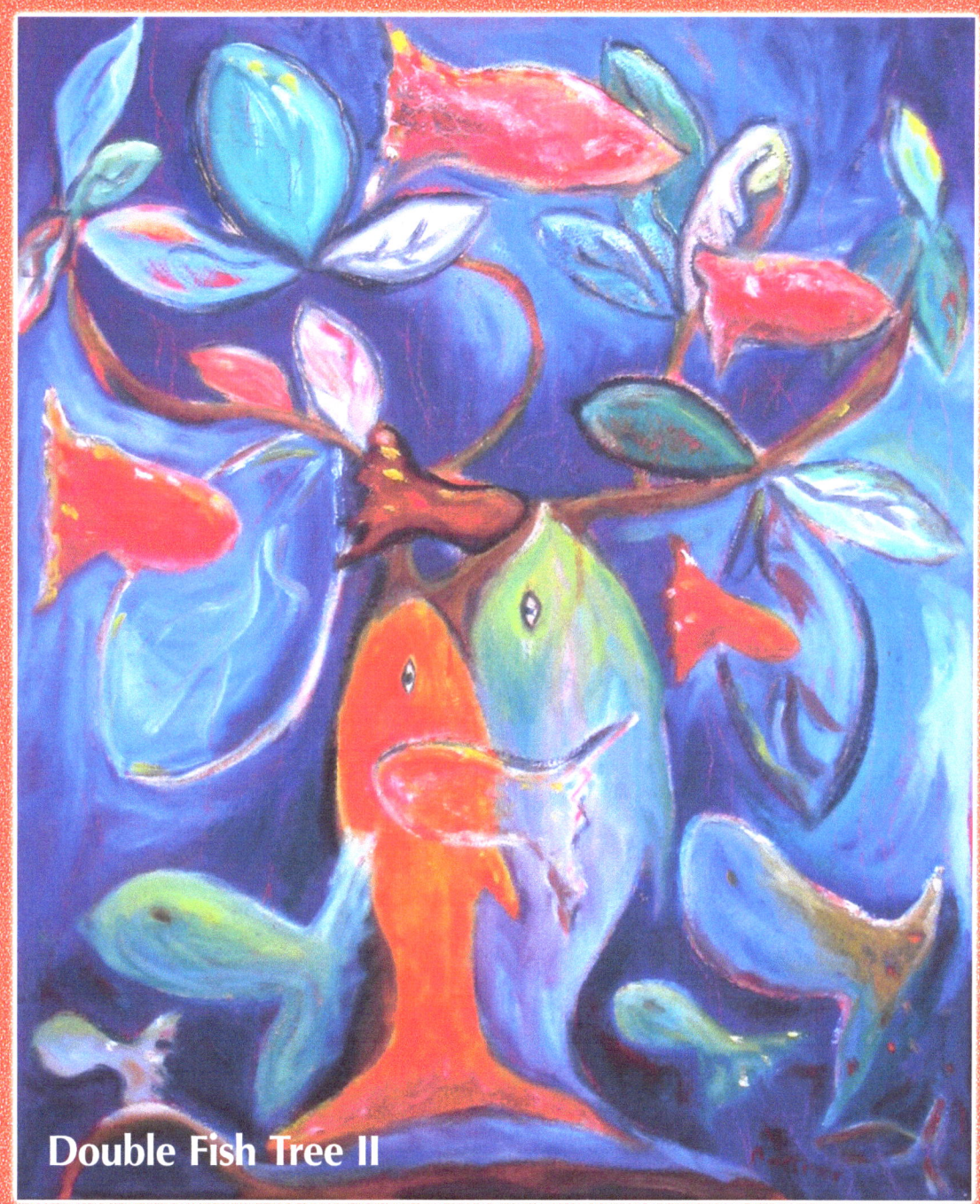

Double Fish Tree II

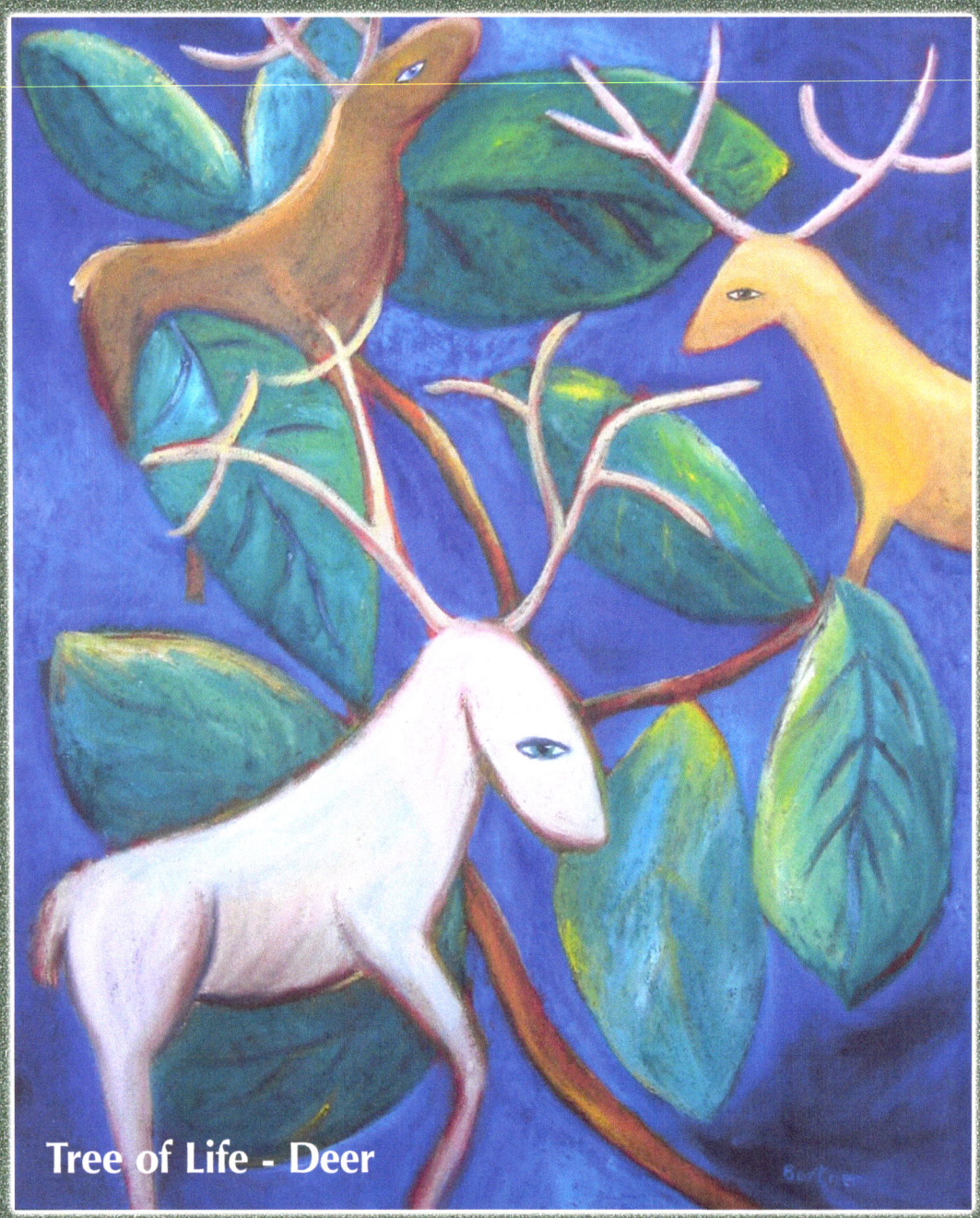
Tree of Life - Deer

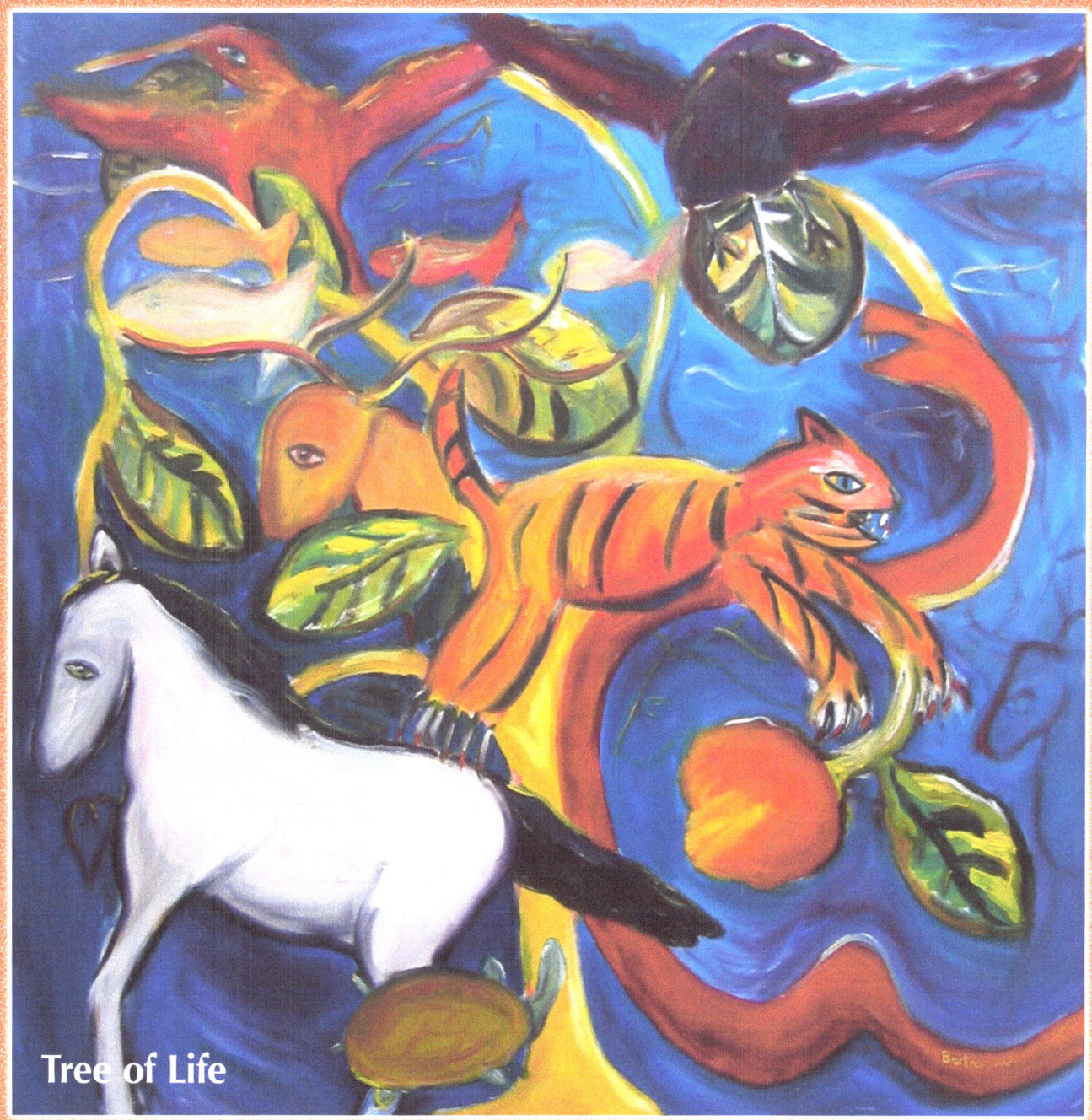
Tree of Life

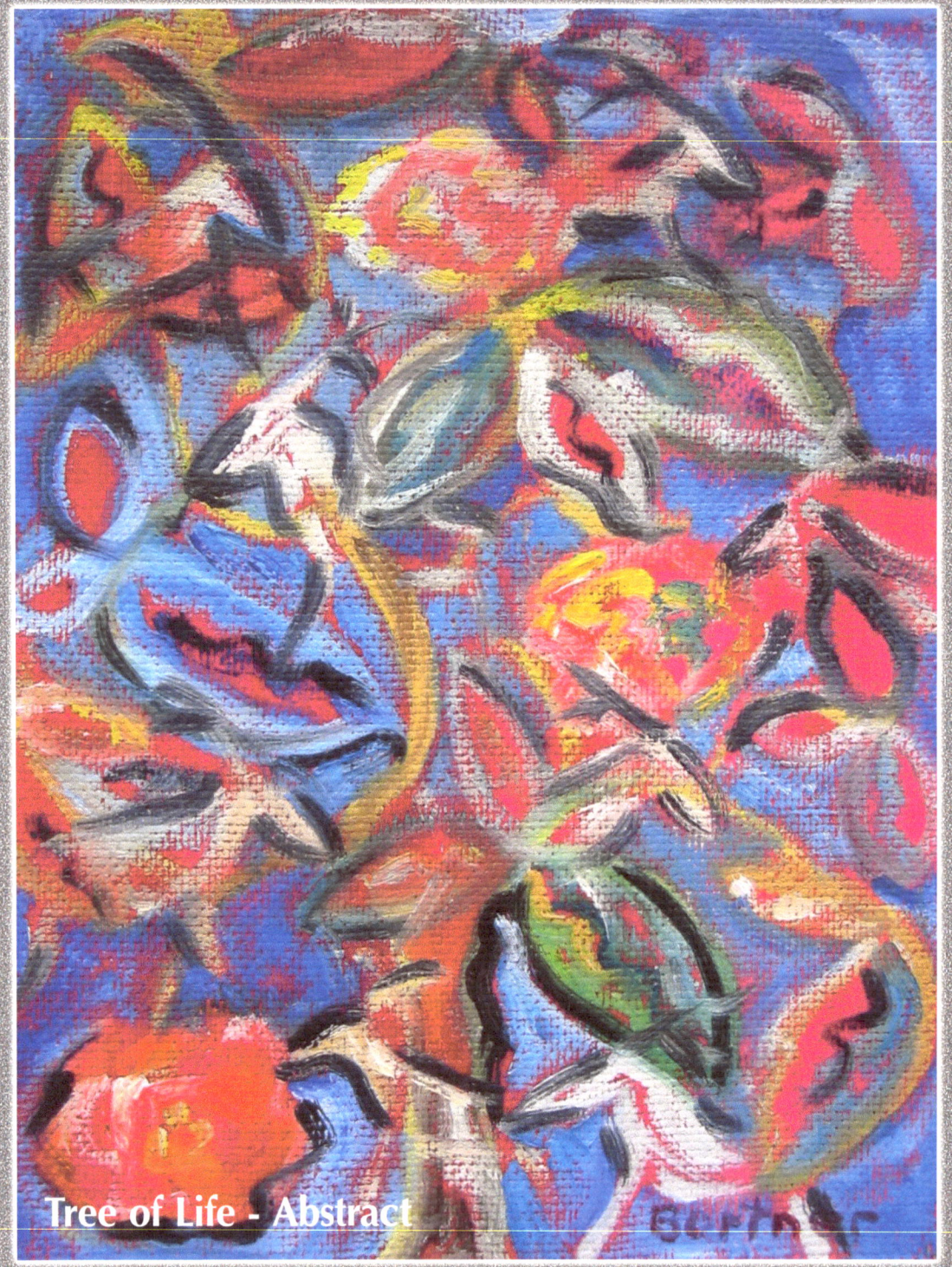

Tree of Life - Abstract

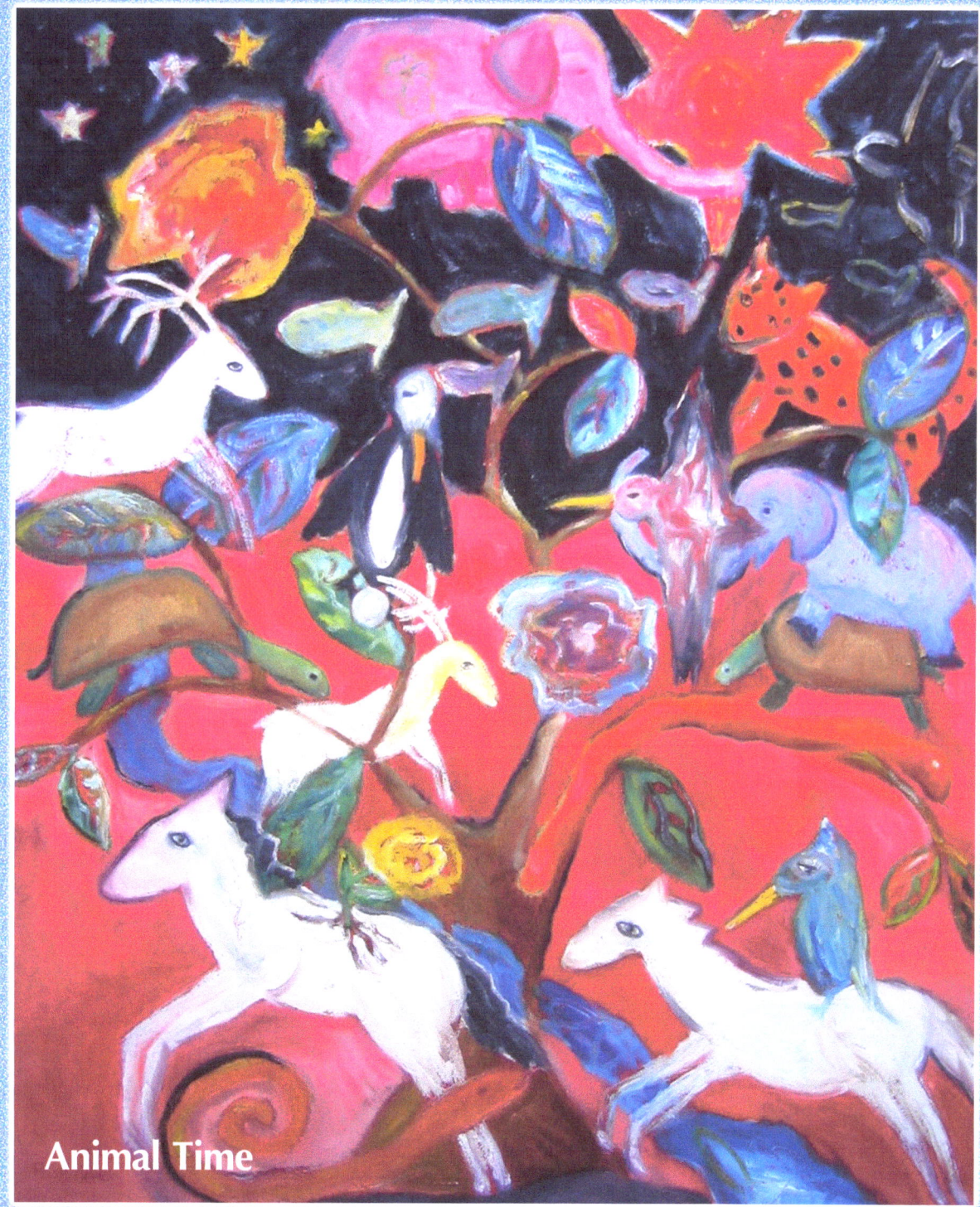

SPIRIT

I remember the spirit, the sacredness that runs through all things, animate and inanimate. Living in New Mexico I am reminded of this through the scenic beauty, diverse cultures and ceremonies.

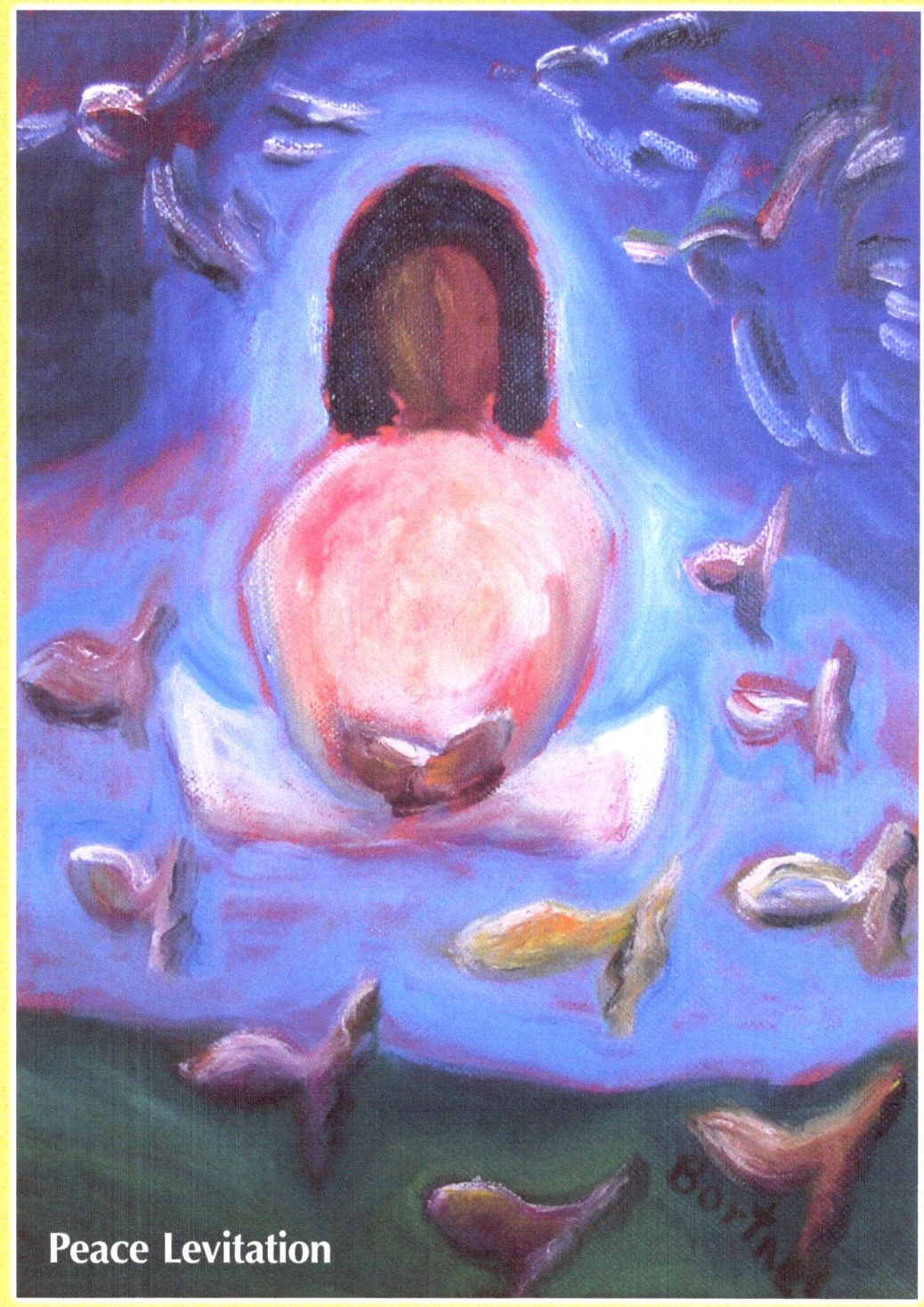

Peace Levitation

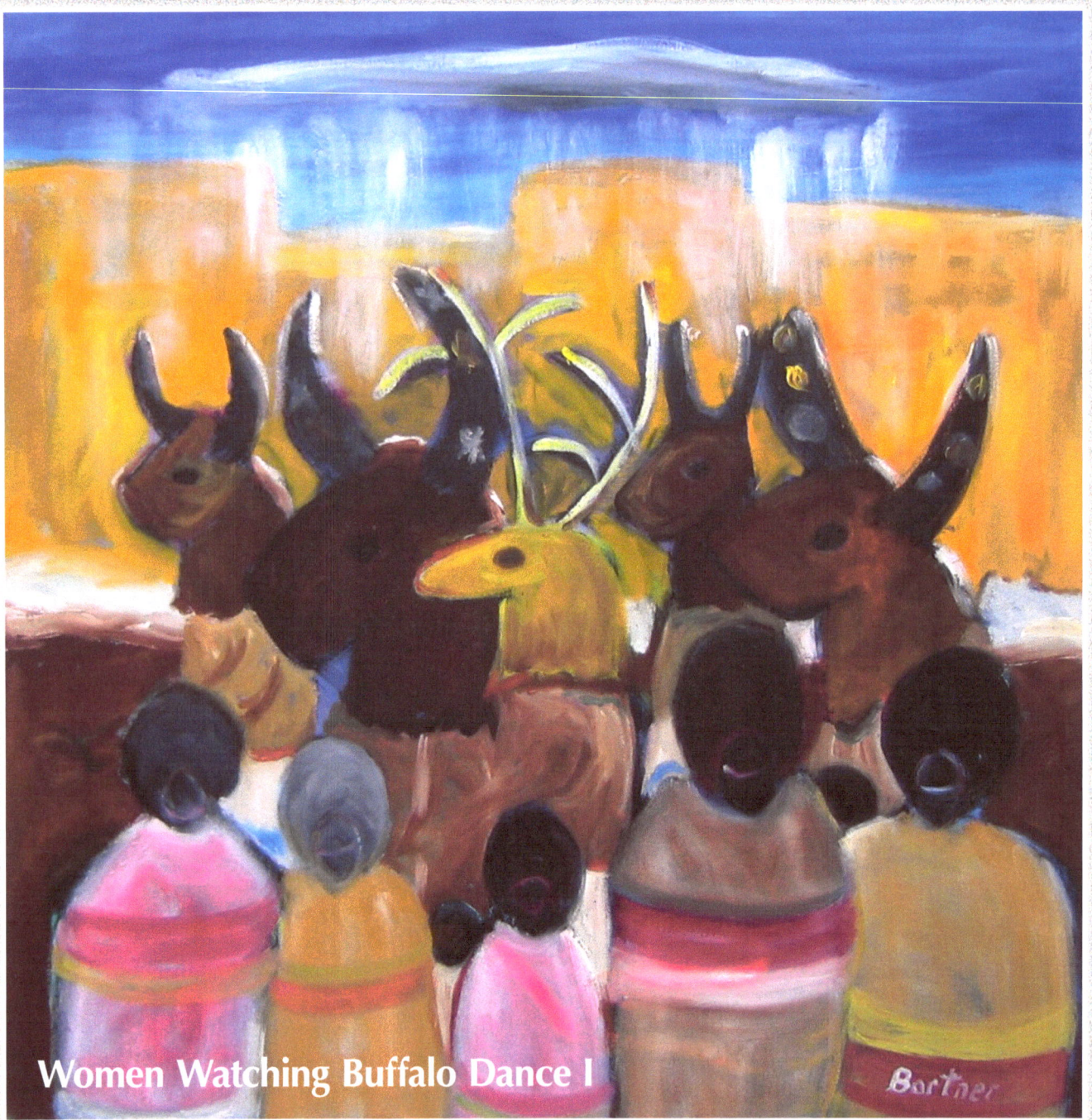
Women Watching Buffalo Dance I

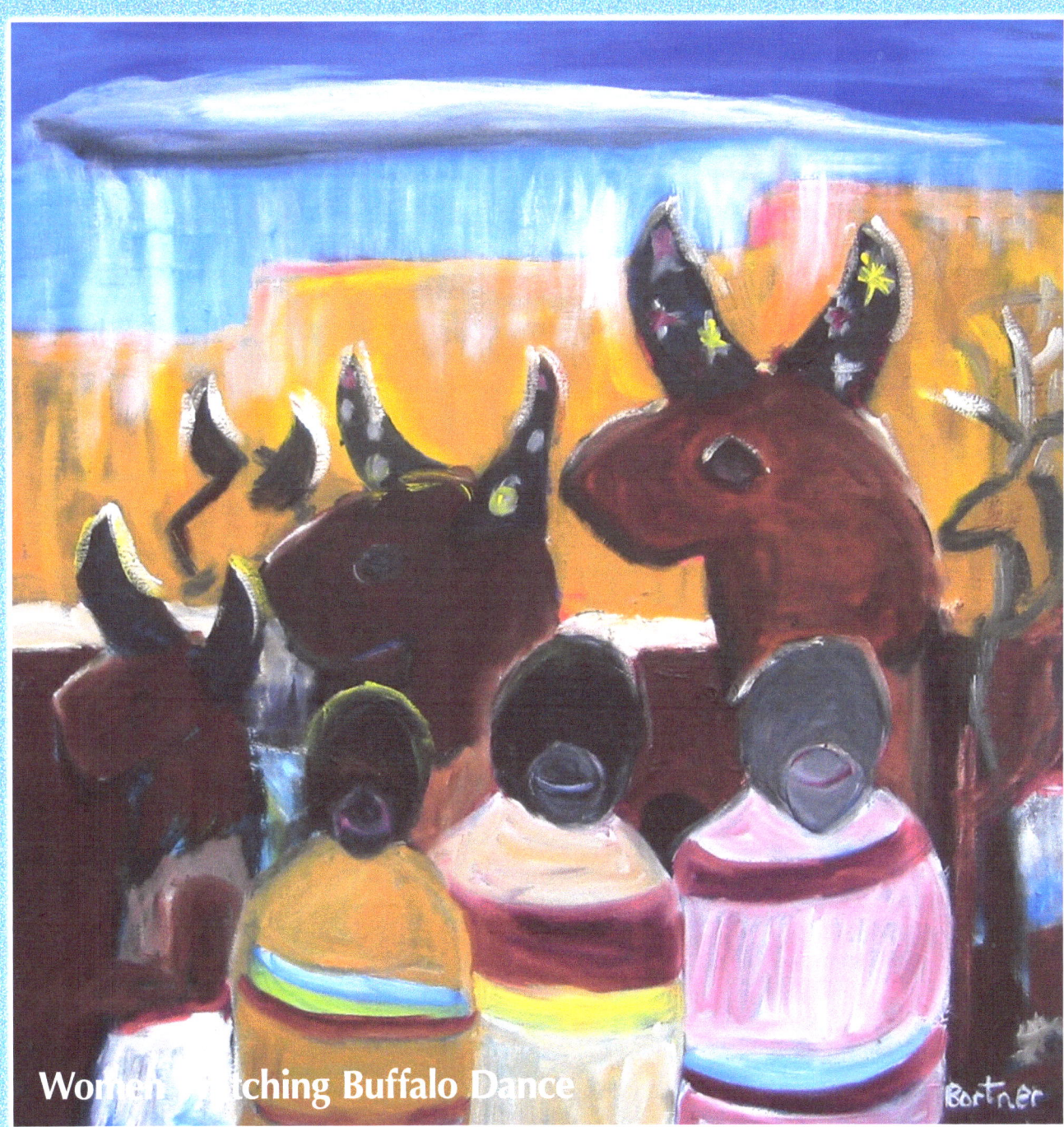
Women Watching Buffalo Dance

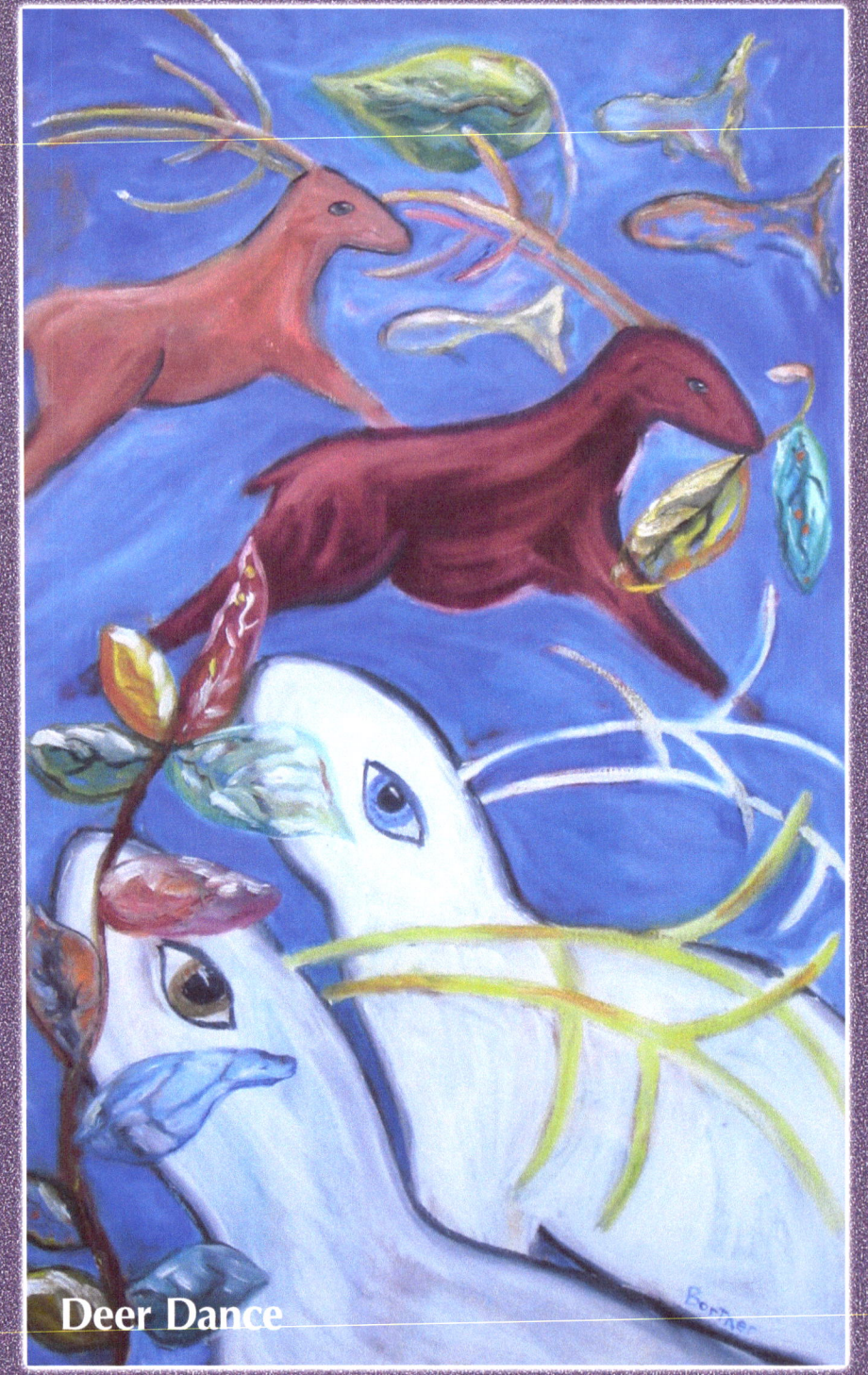

Deer Dance

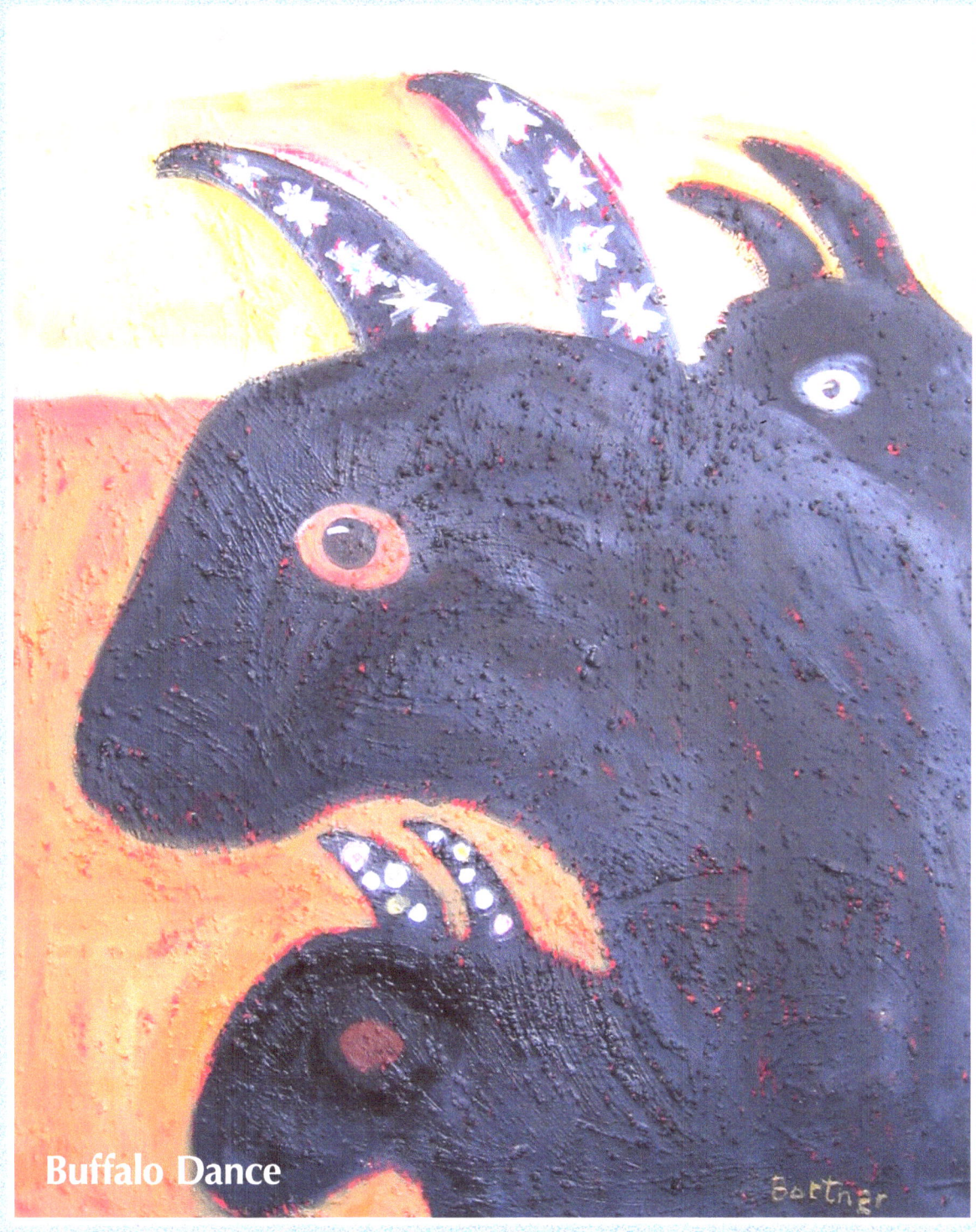

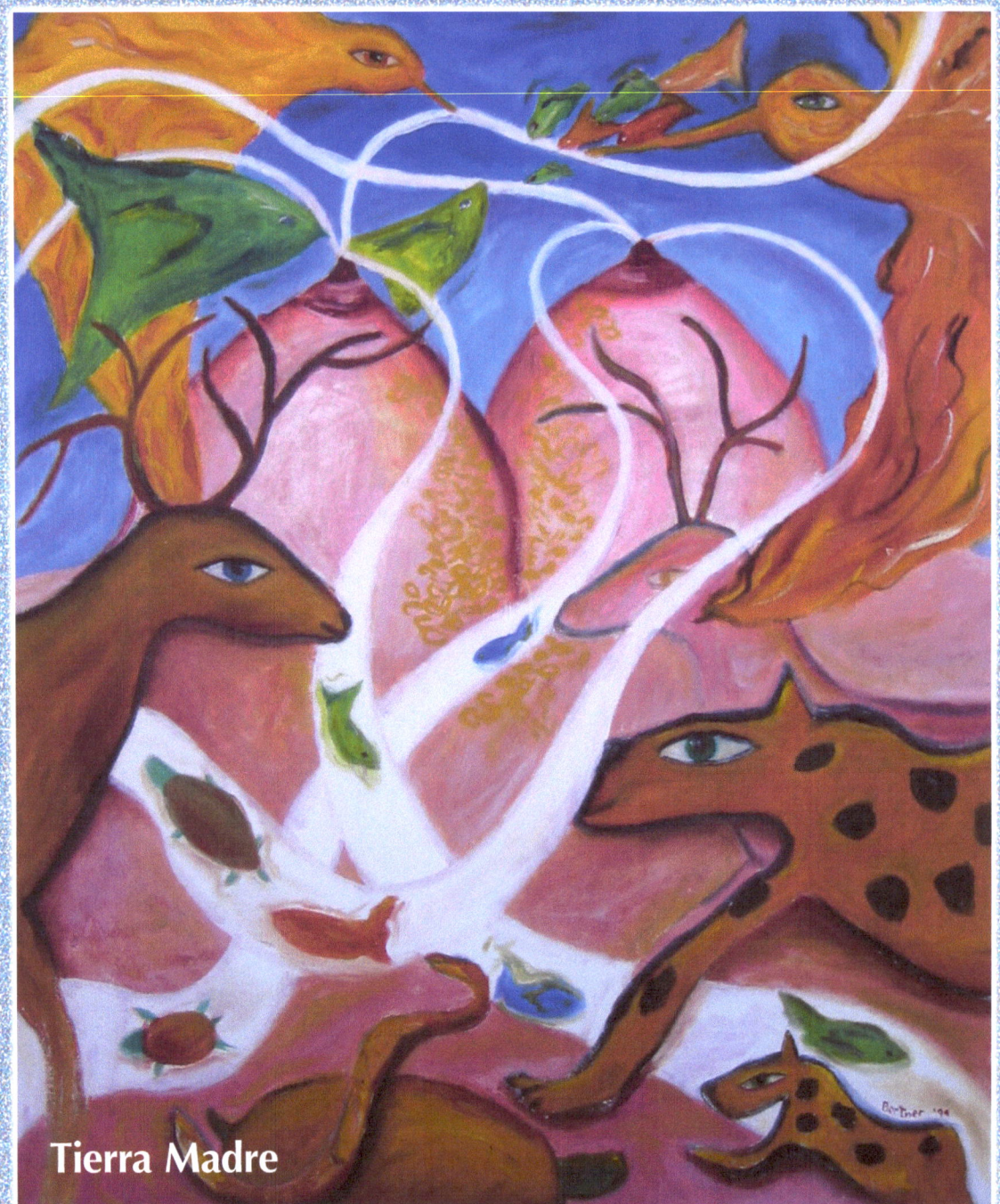
Tierra Madre

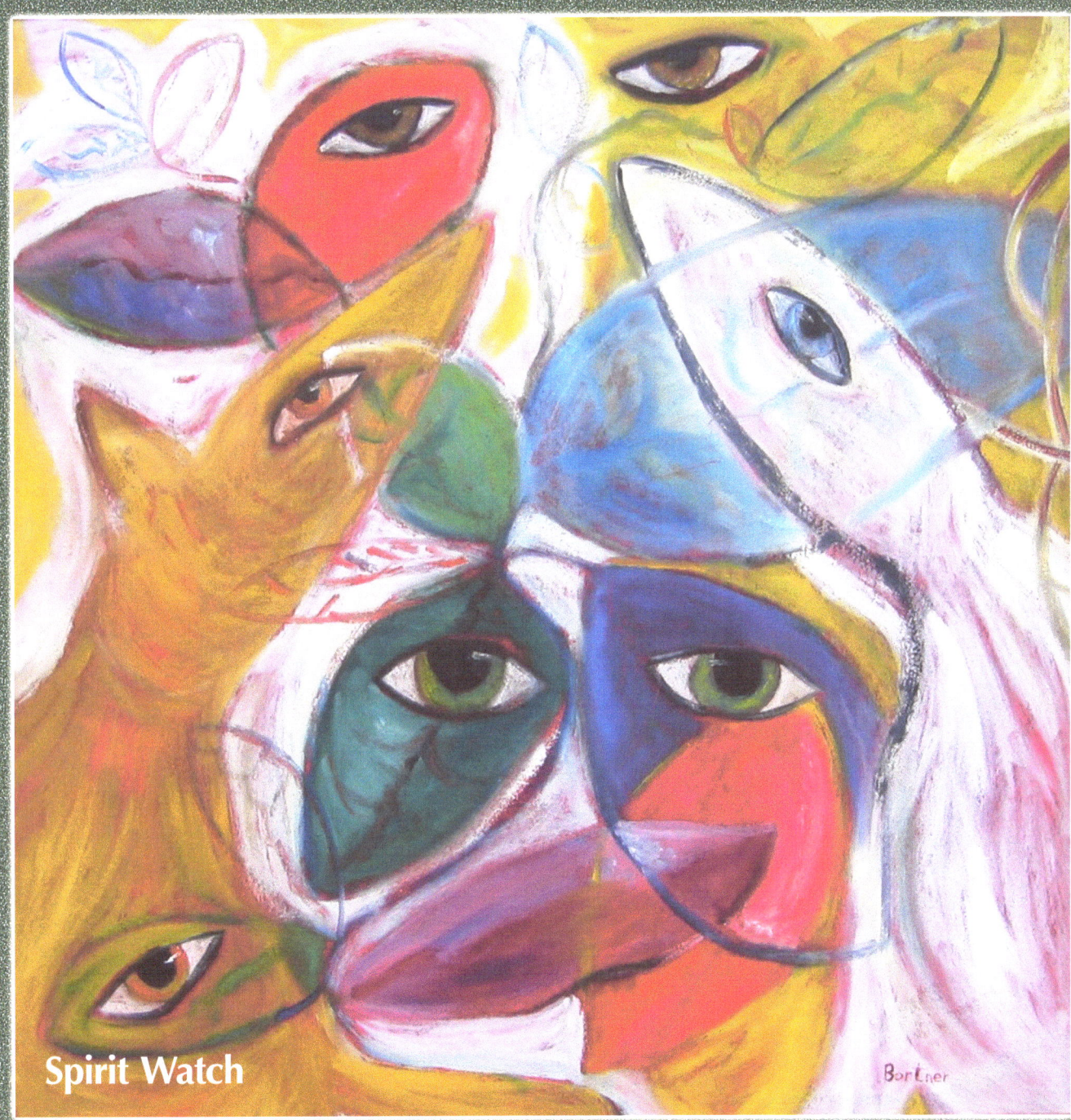

Spirit Watch

WOMEN

Their strength and compassion is the regenerator and perpetuator of this world. The importance of women can never be overstated. Women are the essence of everything. My paintings show rural women and their connection to their animals, children and each other.

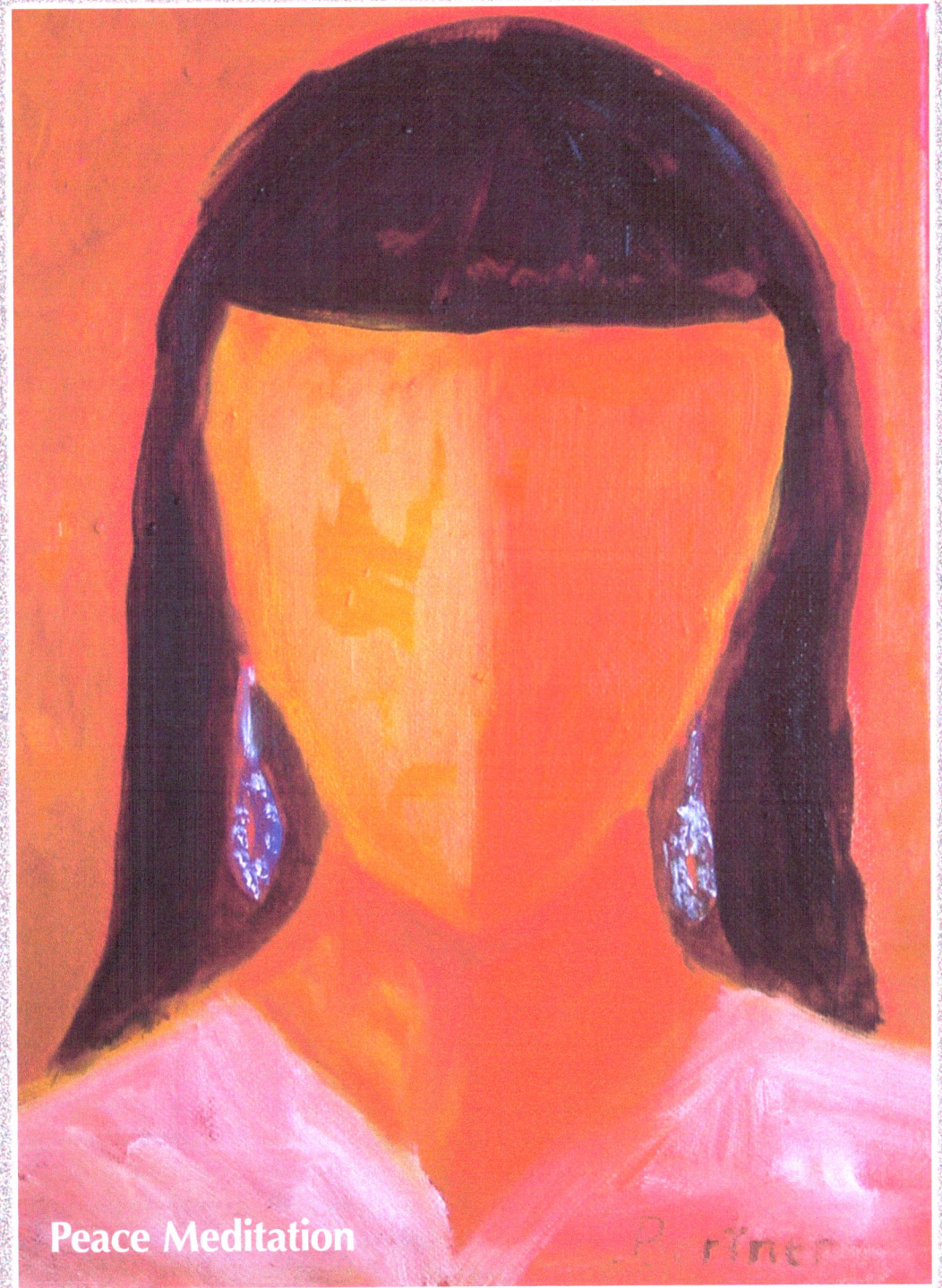

Peace Meditation

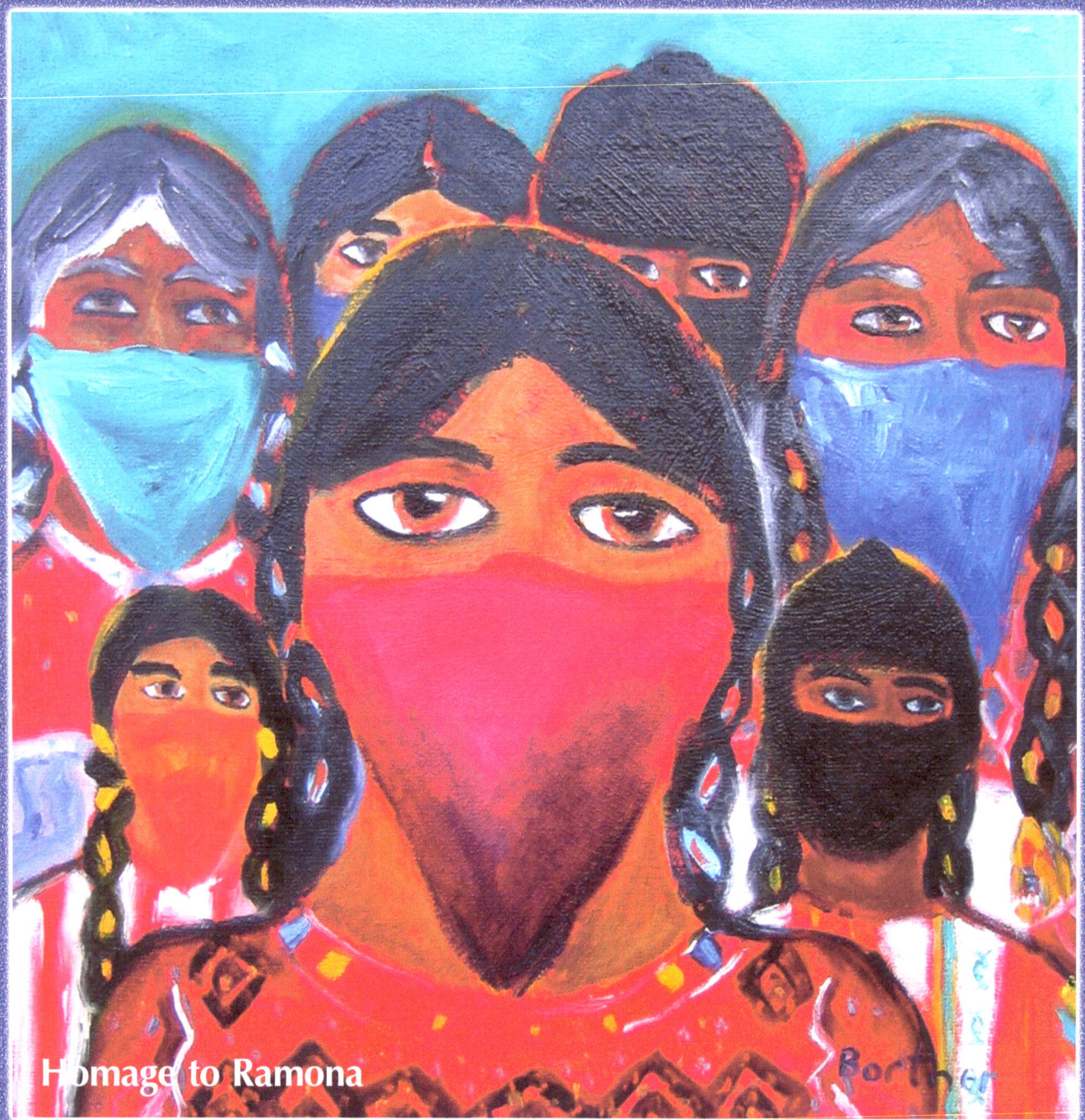

Homage to Ramona

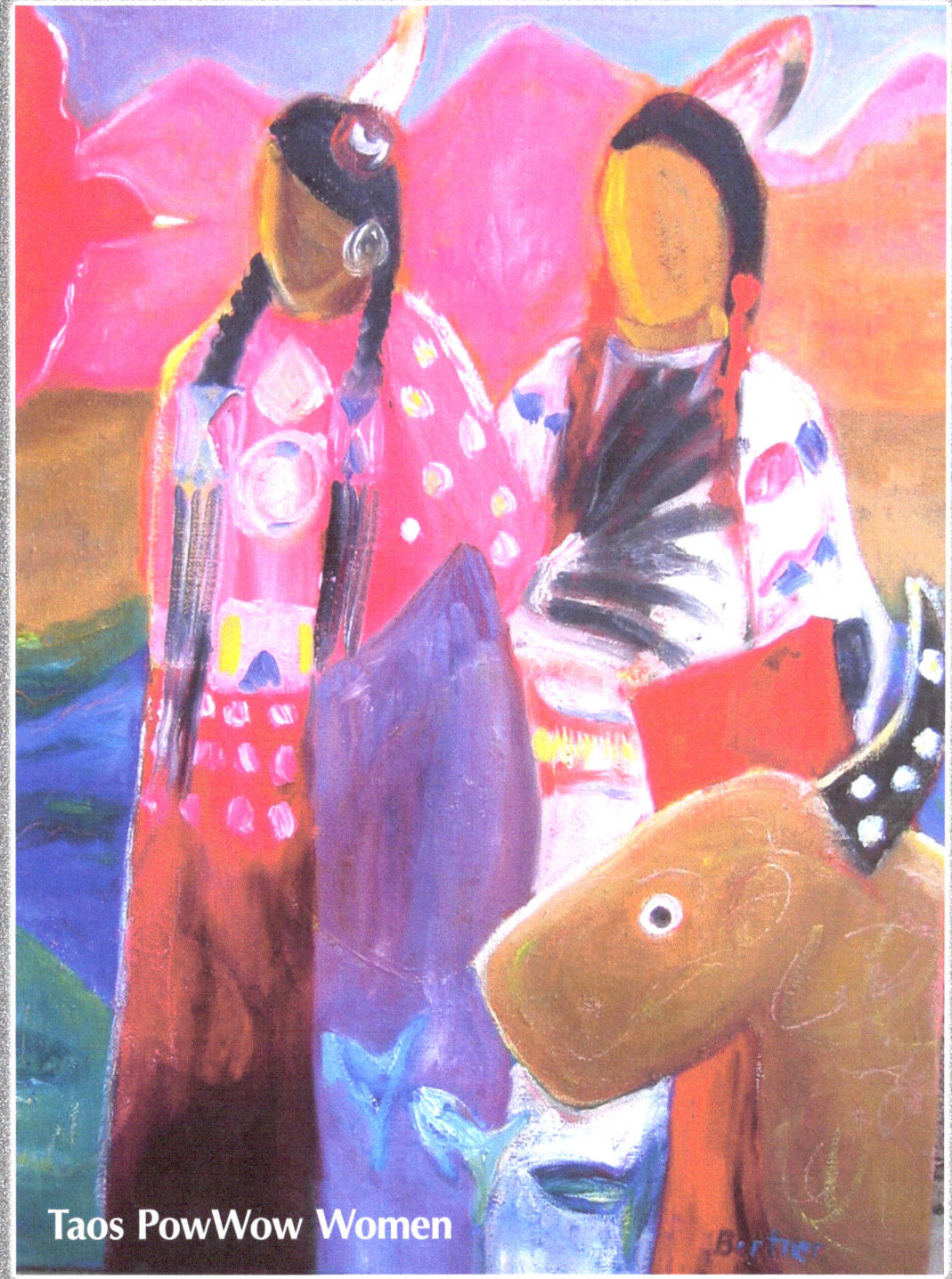

Taos PowWow Women

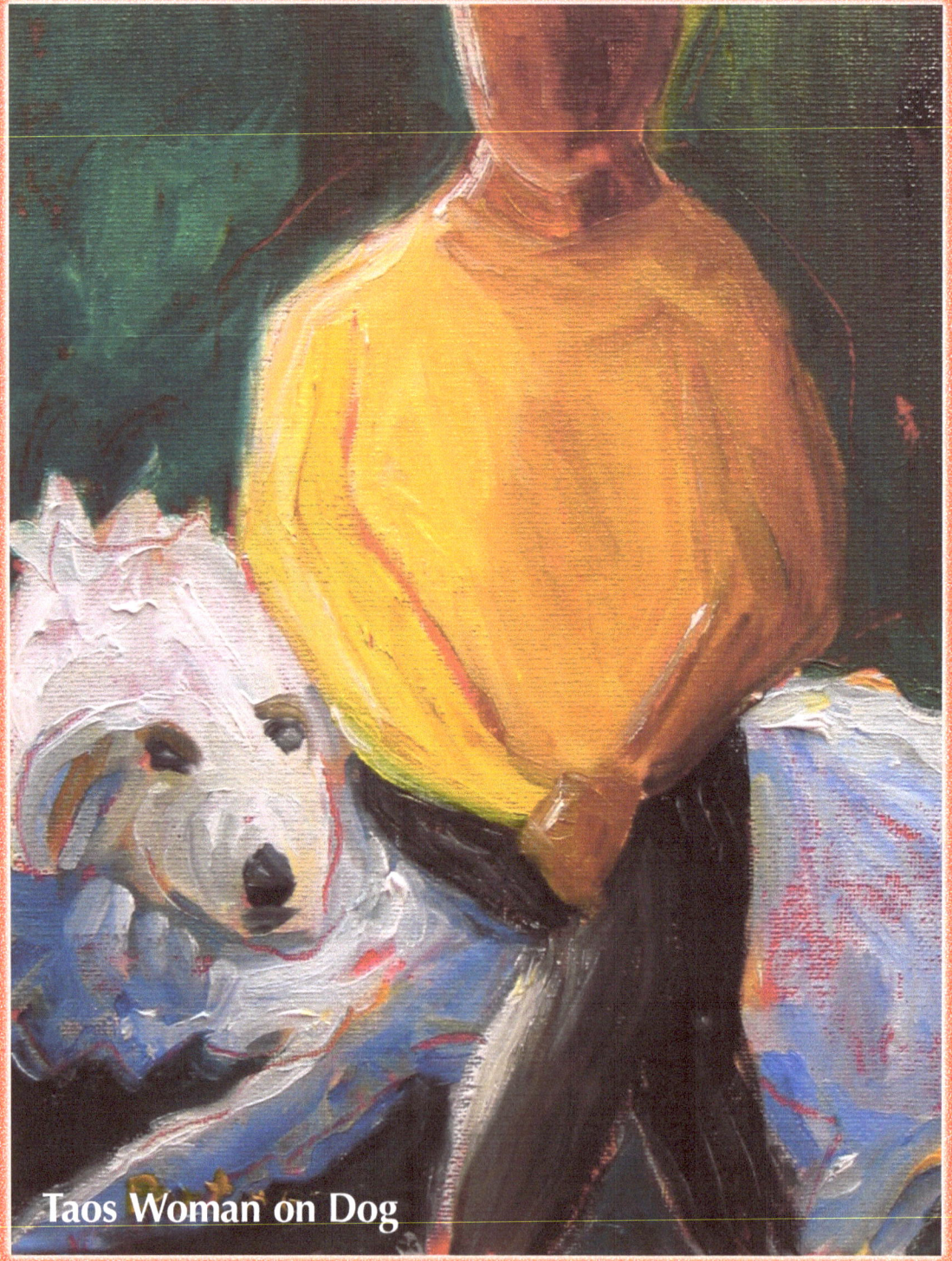

Taos Woman on Dog

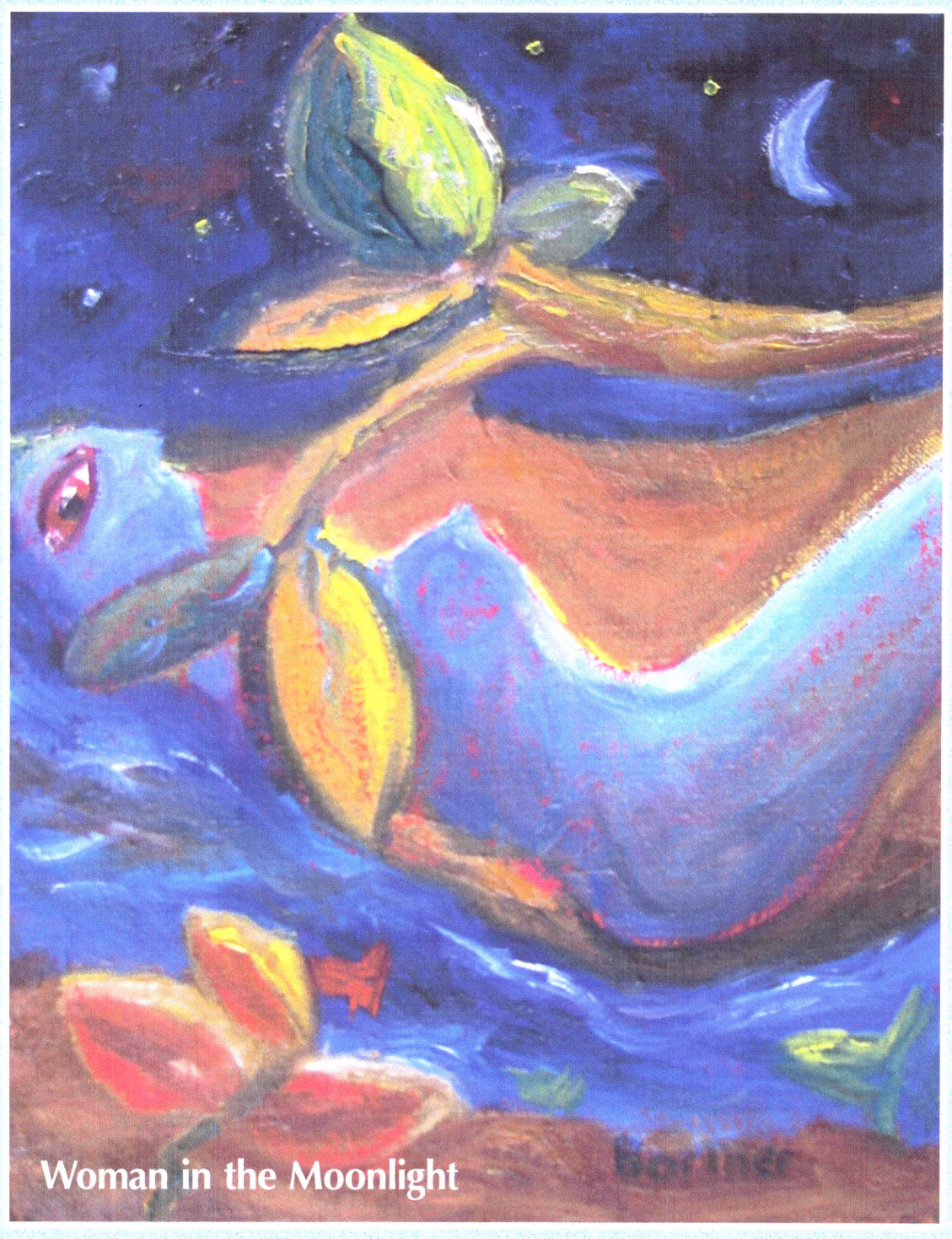

Woman in the Moonlight

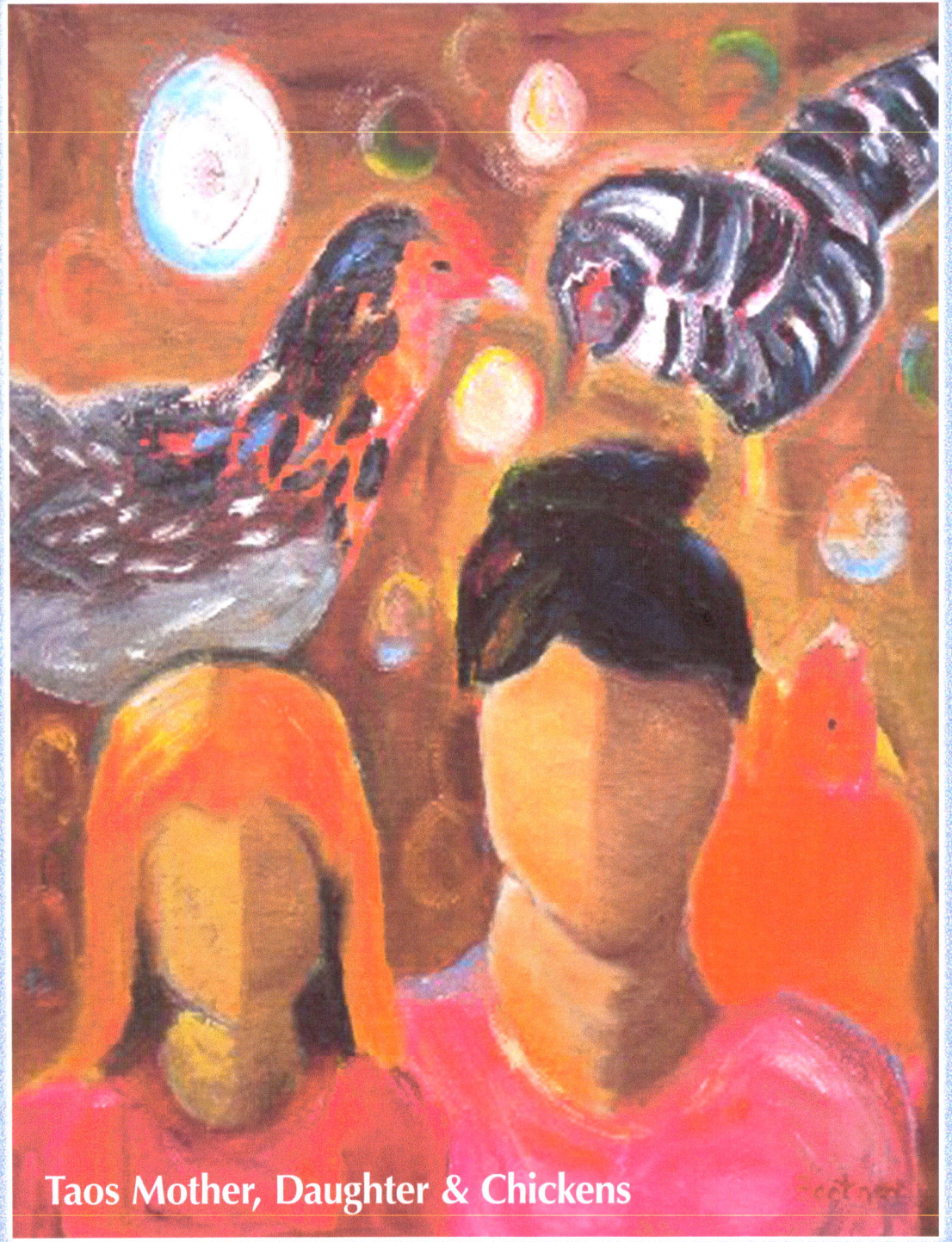
Taos Mother, Daughter & Chickens

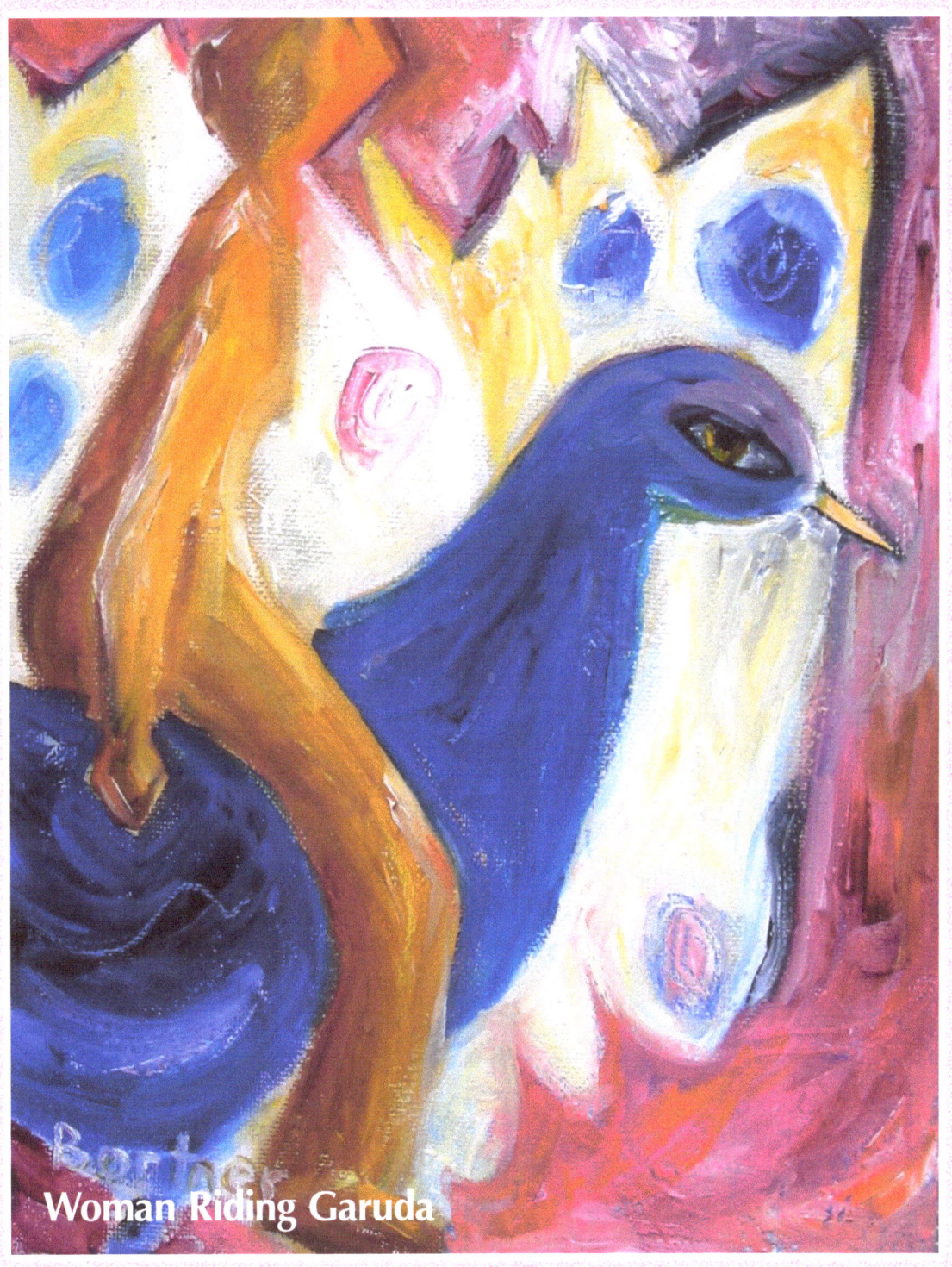

Woman Riding Garuda

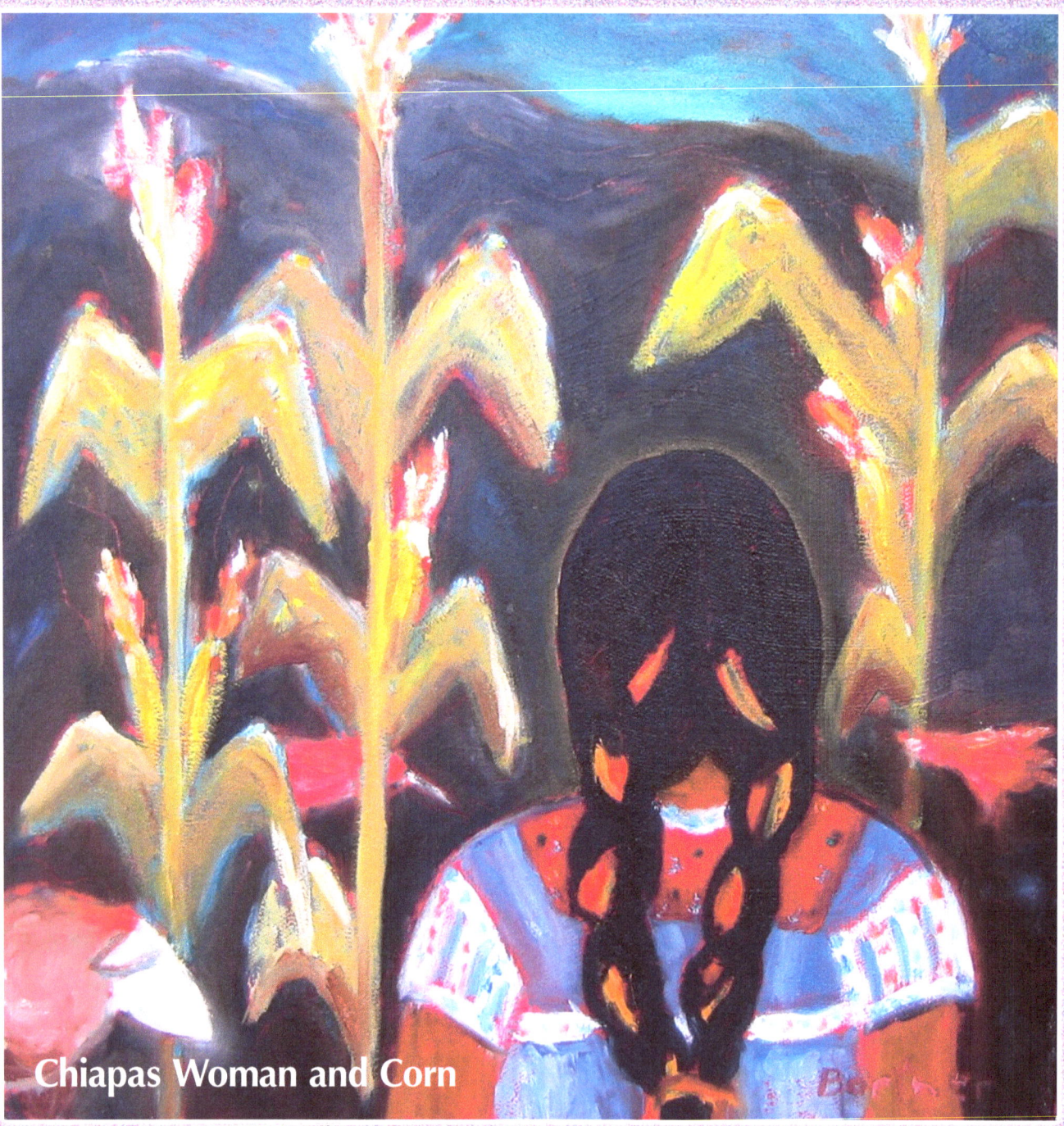

Chiapas Woman and Corn

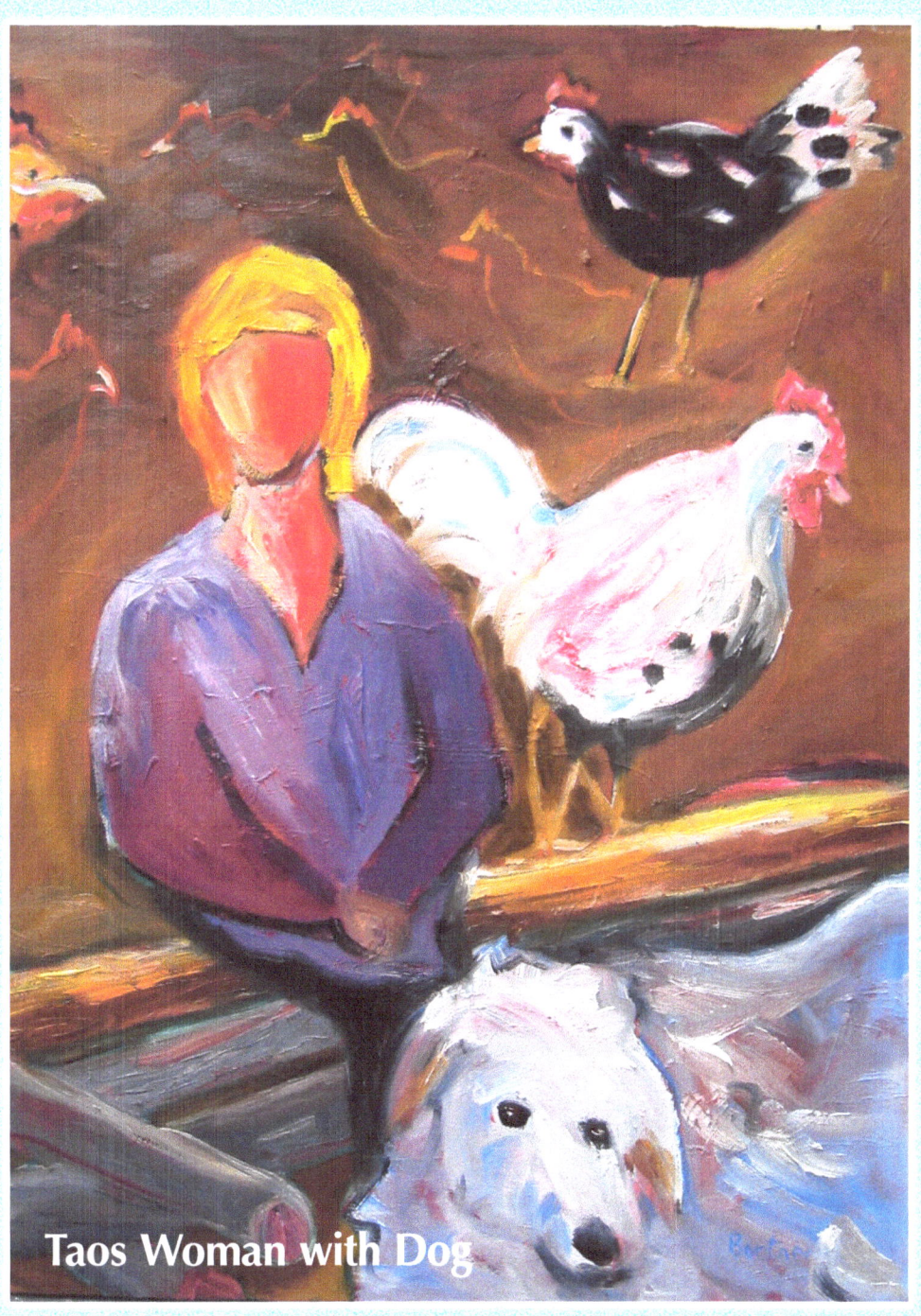

Taos Woman with Dog

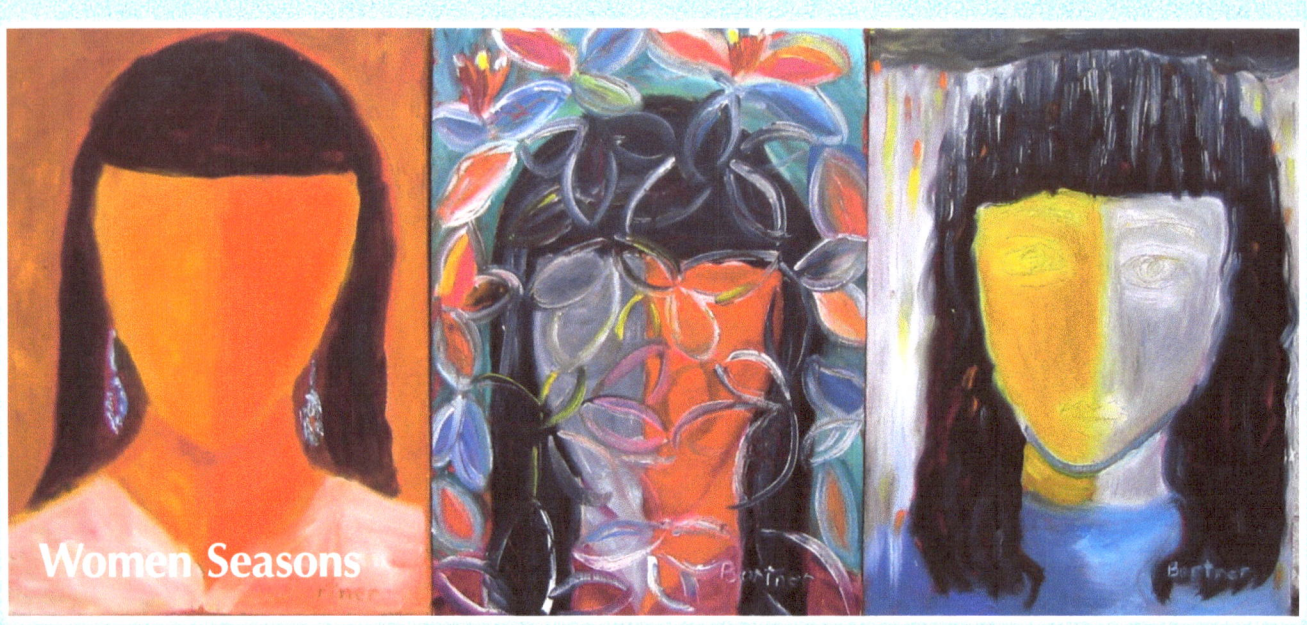

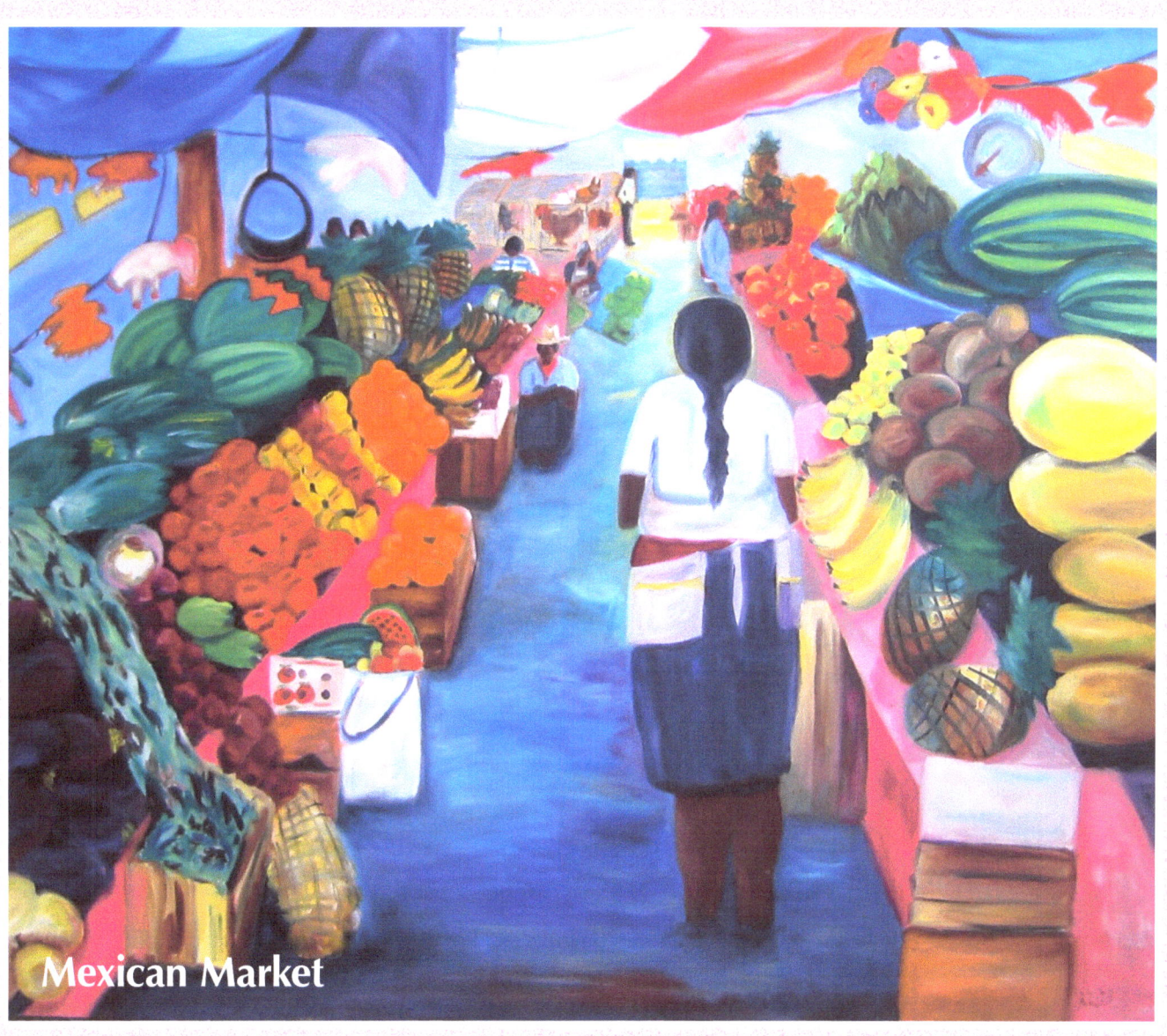

MURALS

After moving to a small adobe house in northern New Mexico I decided to pursue creating murals with youth. There was no space to paint big in my home; murals offered a venue for large scale creations. Inspiring young people in the arts is heartfelt. Creating public art that is accessible to all people is important to me.

Youth from kindergarten through high school have worked creating these murals. The mural locations in Taos, New Mexico are: the Taos Youth and Family Center, Celestino Romero Administration Building, Taos Economic Development Corporation, DreamTree Project, Enos Garcia Elementary School and Early Childhood Center, Taos Charter School and the Yaxche Learning Center. Additional murals are being created yearly.

I would like to thank the following people and organizations for supporting these murals: the Puffin Foundation Ltd, the Healy Foundation, Taos County Economic Development Corporation, New Mexico Educators Federal Credit Union, Taos Mountain Casino, Taos County, City of Taos, Taos Municipal Schools, the Discovery After School Program, ECO Arts, the DreamTree Project, Chevron, Molycorp, Artisans, Randall Lumber and Hardware, and others.

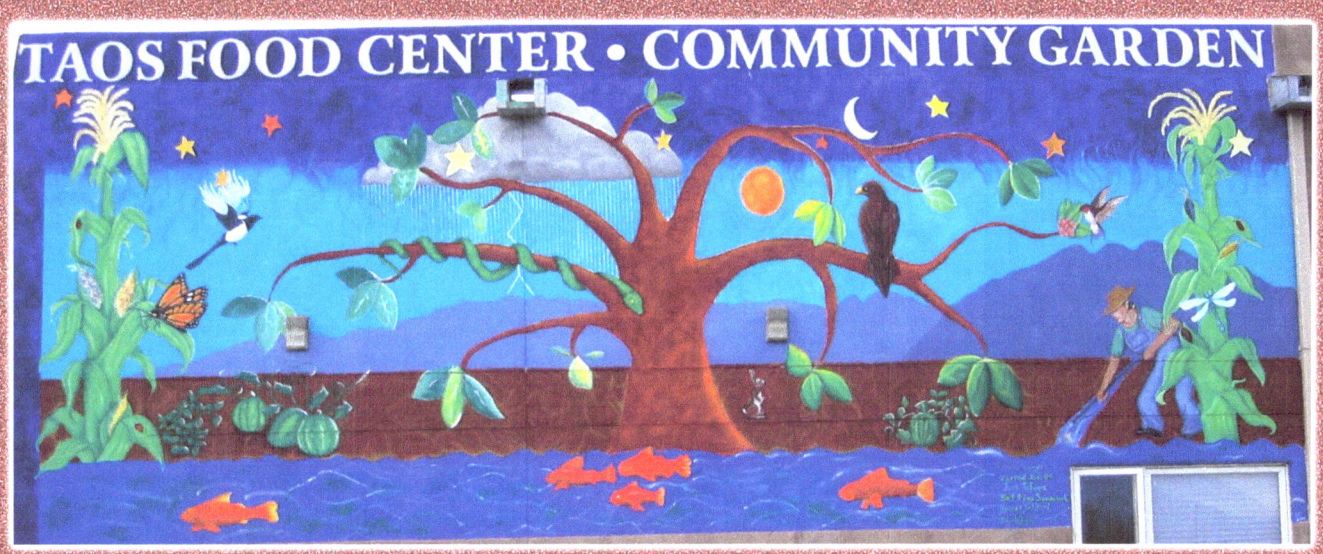

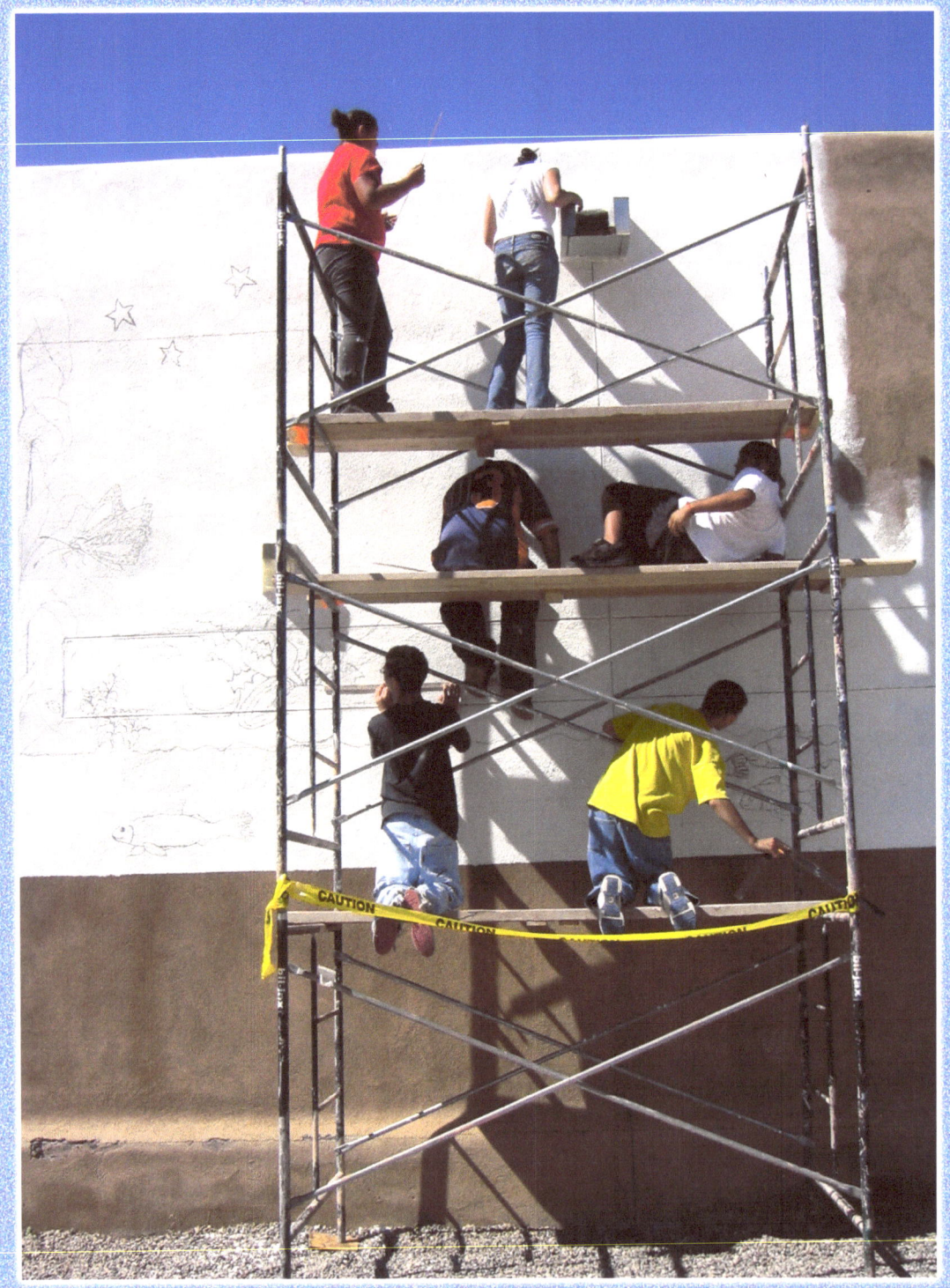

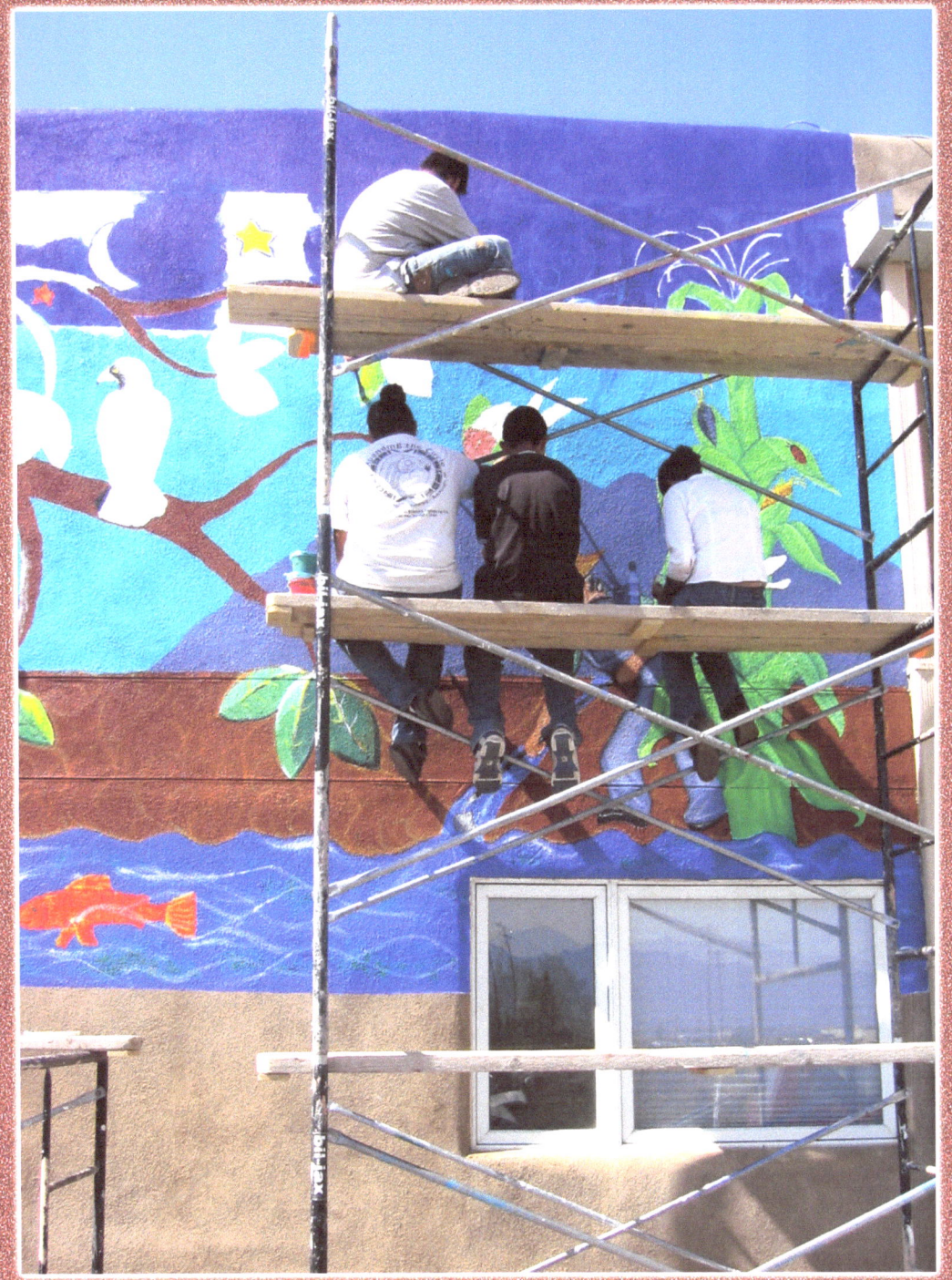

SELECTED EXHIBITIONS

2009, 2005, 2004	Millicent Rogers Museum, *Miniatures*, Taos, NM.
2008	Touchstone, *Venus on a Half Shell*, Taos, NM.
	National Hispanic Cultural Center, *Women Creating Peace*, Albuquerque, NM.
2008, 2007	Emerald Gallery, *International Small Works Show*, Fairfield, IA.
1996-2007	Taos Civic Center, *The Taos Open*, Taos, NM.
2006	El Museo Cultural de Santa Fe, *Aun Nos Atrapan*, Santa Fe, NM.
	National Hispanic Cultural Center, *Women Squared*, Albuquerque, NM.
2005	Mesa Public Library, *Paintings*, Los Alamos, NM.
	Artspace, *Endangered Species*, Albuquerque, NM.
2004	Galleria EliasInez, *Nature: Paintings & Prints*, Ranchos de Taos, NM.
	Museum of Fine Arts, *One of a Kind*, Santa Fe, NM.
2003	Bareiss Gallery, *Art Against War & Empire*, Taos, NM.

2001	Millicent Rogers Museum, Sobre Muerte: *Altars in Celebration of All Souls' Day,* Taos, NM. Taos Inn, *Meet the Artists,* Taos, NM.
2000	Fisher Gallery, *Rainbow Artists.com,* Albuquerque, NM.
1999	Ashcraft Gallery, *Images of the Southwest,* Rio Rancho, NM.
1998	San Acadia Gallery, *La Vida del Rio, Life of the River,* NM.
1997	Cedar Rapids Museum of Art, *Showing Off,* Cedar Rapids, IA. Guadalupe Fine Arts, *Woman of the Night,* Santa Fe, NM.
1995	The Corn Maiden, *Shakti: The Feminine Power,* Taos, NM. Kimo Theater Gallery, *Conjuncto en Julio,* Albuquerque, NM.
1994	College of St. Mary, Dana College, *Bad Girls Midwest,* NE. Len Everett Gallery, Monmouth College, *The Body Politic,* IL.
1993	The Grove Gallery, *Featured Artist,* Naples, FL.
1992	Arts for Living Center, *Animals, Places: Then & Now,* Burlington, IA.
1990	Nancy Lurie Gallery, Chicago, IL.

COLLECTIONS AND PUBLIC WORKS

Holy Cross Hospital, Taos, NM, Childhaven, Farmington, NM, Temple Beth Shalom, Fairfield, IA. Private collections.

Murals with youth: Taos, NM: Celestino Romero Administration Building, Taos Youth and Family Center, Yaxche Learning Center, DreamTree Project, Taos County Economic Development Corporation, Taos Charter School, Enos Garcia Elementary School, and La Plaza Telecommunity. Albuquerque, NM: Los Altos/Alamosa, Bridge Blvd and Old Coors.

PUBLICATIONS

The Taos News, *The Tempo, The Creative Edge*, "Creating Peace", March 6-12, 2008.

The Taos News, *The Tempo*, "Keeping Taos Beautiful", July 20-26, 2006.

www.cezanescarrot.org/vol1iss2/index.html, ISSN 1930-2878, Vernal Equinox, 2006.

La Monitor, *Kaleidoscope*, "Lush colors will energize the winter - weary", Thursday, February 24, 2005.

The Taos News, *The Tempo*, "Artist fills an educational niche", May 6-12, 2004, pg 23-24.

The Taos News, *The Tempo*, "Art transforms a city neighborhood", November 20, 1997, Sec C.

Albuquerque Journal, "Mural depicts area's history", October 12, 1997, C2.

The Albuquerque Tribune, "City mural swirls together an area's past, present, future", November 7, 1997, B1, B6.

Ski Country, *"A Late Model Affair"*, Winter 1996-97, p 27.

Intimate Communion: Awakening Your Sexual Essence, cover art, 1995.

The Taos News, *The Tempo*, "The power of the feminine principle", October 19, 1995, B5.

Woman's Way, art, Fall Issue, 1995.

The Fairfield Weekly Reader, "The Magical Kingdom of Lorrie Bortner", September, 17-23, 1992.

ARTIST RESIDENCIES

Virginia Center for the Creative Arts

Vermont Studio Center

ART EDUCATOR

Taos Municipal Schools, Taos, NM: *Artist-In-The-Schools* and *Enrichment Specialist*, Art, *Discovery After School Program*.

Yaxche Learning Center, Taos, NM. Artist-in-Residence.

Private classes for adults and children.

AWARDS & RECOGNITION

2008, 2007 *Certificate of Appreciation,* Taos Municipal Schools, NM.

2008 *Principal's Award,* Arroyos del Norte Elementary School, Arroyo Seco, NM.

2000 *Certificate of Appreciation,* La Plaza Telecommunity, Taos, NM.

GRANTS

2008, 2006 Puffin Foundation Ltd.

1999, 2000 Open Studio: The Arts On Line, La Plaza Telecommunity, NM.

1991, 92, 93, 94 Iowa Arts Council, Artists Grants.

EDUCATION

MFA, MA, Maharishi International University, Fairfield, Iowa.

MSCI, BSCI, Maharishi European Research University, Switzerland.

Webster College, St. Louis, Missouri.

PAINTINGS

Animals

1 Magpie Over Cundiyo, 42" x 42", oil and gold leaf, 1995.
2 Autumn Rabbit and Buffalo, 31" x 41", mixed media, 2007.
3 Spring Rabbit Run, 9" x 12", mixed media, 2006.
 Collection of the artist.
4 Animal Whispers, 41" x 62", diptych, mixed media, 2004.
5 Miss Polka Dot, 12" x 9", mixed media, 2007.
6 Taos Animals, 18" x 14", mixed media, 2007.
7 Deer and Fish, 29" x 48", diptych, mixed media, 2006.
8 Tonto, 31" x 31", oil, 1988.
9 Fauvist Winter, 26" x 22", mixed media, 2008.
10 Yucan's Field, 18" x 20", oil, 1996.
11 Sunrise Aria, 22" x 26", oil, 1996.
12 Laughing Lizard, 24" x 28", oil, 1990.
13 Pelicans, 24" x 28", oil, 1990.

Trees

14 Transparent Life, 30" x 40", mixed media with gold leaf, 2002.
 Collection of the artist.
15 Winter Tree, 10" x 8", mixed media, 2008.
16 Beautiful Tree, 10" x 8", mixed media, 2007.
17 Tree of Life – Night, 26" x 22", mixed media, 2000.
 Collection of the artist.

18 Untitled, 30" x 24", mixed media, 2003.
19 Transparent Life II, 28" x 44", diptych, mixed media, 2002.
20 Fish Forest II, 41" x 41", oil, 2005.
21 Double Fish Tree II, 24" x 20", mixed media, 2004.
 Collection of Liberty National Financial Corporation, Oklahoma.
22 Tree of Life – Deer, 26" x 22", mixed media, 2003.
 Collection of the artist.
23 Tree of Life, 36" x 36", mixed media, 2000.
24 Tree of Life – Abstract, 12" x 8", mixed media, 2002.
25 Animal Time, 37" x 31", mixed media, 2004.

Spirit

26 Peace Levitation, 12" x 9", mixed media, 2008.
27 Women Watching Buffalo Dance I, 24" x 24", mixed media, 2008.
28 Women Watching Buffalo Dance, 24" x 24", mixed media, 2008.
29 Deer Dance, 24" x 16", mixed media, 2004.
30 Buffalo Dance, 24" x 20", mixed media, 2007.
 Collection of Patsy Dale Allen, New Mexico.
31 Tierra Madre, 26" x 22", oil, 2000.
32 Spirit Watch, 30" x 30", mixed media, 2003.

Women

33 Peace Meditation, 12" x 9", mixed media, 2007.
34 Homage to Ramona, 12" x 12", mixed media, 2007.
 Collection of Olga Torres-Reid, New Mexico.
35 Taos PowWow Women, 18" x 14", mixed media, 2007.
36 Taos Woman on Dog, 10" x 8", mixed media, 2007.

37 Woman in the Moonlight, 10" x 8", mixed media, 2007.
 Collection of the artist.
38 Taos Mother, Daughter & Chickens, 18" x 14", mixed media, 2007.
39 Woman Riding Garuda, 10" x 8", mixed media, 2007.
40 Chiapas Woman and Corn, 12" x 12", mixed media, 2006.
41 Taos Woman with Dog and Chickens, 24" x 18", mixed media, 2007.
42 Women Seasons, 9" x 24", triptych, mixed media, 2008.
43 Mexican Market, 52" x 40", oil, 1988.
 Private collection, New Mexico.

Murals

44 Tree of Life, Mural, 20' x 33', Taos County Economic Development Corporation building , Bertha Street, Taos, NM, 2006.
 Artists: Lorrie with Taos High School Artists: Kristina BadHand, Miguel Garcia, Bettina Sandoval, Josh Tafoya and Jarrod Torres.
45 Drawing the mural.
46 Painting the mural.

INFORMATION

In 1995, Lorrie and her artist husband moved to the mountains of northern New Mexico. They both enjoy the visual beauty of the mountains and living a rural lifestyle.

Lorrie is involved with art in the schools and working with youth on mural projects in the community.

She is available for private or public commissions, murals, and classes. Many of the original paintings in this book are available for purchase.

Her work can be seen at www.lorriebortner.com or by appointment.

E mail: lorriebortner@yahoo.com

See 1stWorld Books at:

www.1stWorldPublishing.com

See our classic collection at:

www.1stWorldLibrary.com

www.ingramcontent.com/pod-product-compliance
Lightning Source LLC
Chambersburg PA
CBHW051023180526
45172CB00002B/452